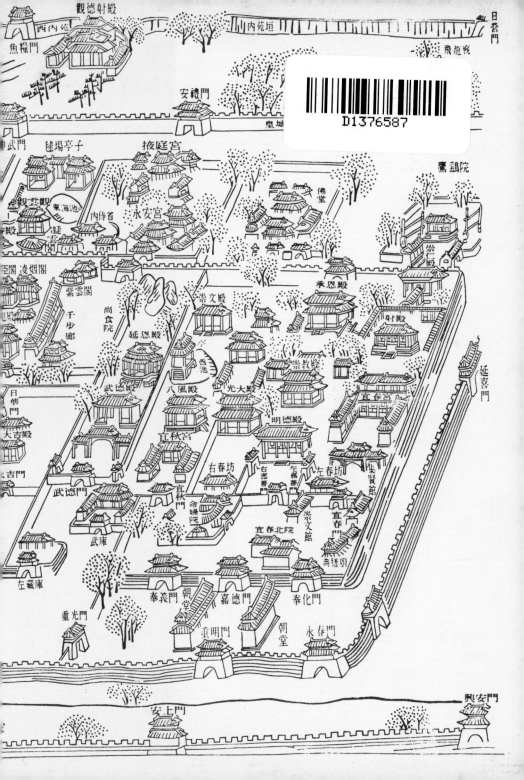

WANG WEI
THE
PAINTER-POET

1. *Frontispiece:* "Wang Wei Playing His Lute," by Ôkyo Maruyama, from the collection of Tsunekichi Ogura, Esq., Tokyo.

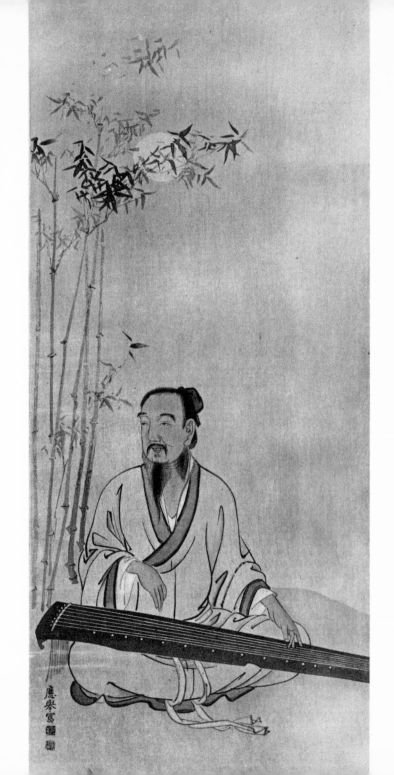

Wang Wei
the Painter-Poet

by

Lewis Calvin &

Dorothy Brush Walmsley

Charles E. Tuttle Company: Publishers

Rutland, Vermont Tokyo, Japan

Representatives
Continental Europe: BOXERBOOKS, INC., Zurich
British Isles: PRENTICE-HALL INTERNATIONAL, INC., London
Australasia: PAUL FLESCH & CO., PTY. LTD., Melbourne
Canada: M. G. HURTIG LTD., Edmonton

Published by the Charles E. Tuttle Company, Inc.
of Rutland, Vermont & Tokyo, Japan
with editorial offices at
Suido 1-chome, 2–6, Bunkyo-ku, Tokyo, Japan

Copyright in Japan, 1968, by
The Charles E. Tuttle Company, Inc.
First edition, 1968

Book design and typography by
Roland A. Mulhauser

Library of Congress Catalog Card No. 68–21117

PRINTED IN JAPAN

CONTENTS

ILLUSTRATIONS

The Romanization followed in the text is "a slightly modified adaptation of Wade's Syllabary" found in Matthew's *Chinese-English Dictionary*. For geographical terms a common form of Romanization has been used: Hyphens have been frequently inserted for ease in pronouncing Chinese words. In the case of personal names, the Anglicized forms used by the persons themselves have been employed.

ACKNOWLEDGMENTS

THE AUTHORS ARE deeply conscious of their indebtedness to many persons who have generously assisted in the preparation of this book.

We owe our greatest indebtedness to Dr. C. C. Shih of the Department of East Asian Studies in the University of Toronto. He read in Chinese most of the available sources on the life and work of Wang Wei. He prepared the Chinese bibliography and contributed many important insights.

Alice Boney of Tokyo spared no effort in procuring photographs of paintings from private collections and galleries in Japan, a rich repository of T'ang China's culture. Louise Stone assisted with this formidable task. Chang Yin-nan, collaborator on *Poems by Wang Wei,* patiently read the text and offered needed criticism. Raymond Chu, Librarian of the Chinese Division in the Library of the University of Toronto, directed us to most helpful references.

We thank also the many authors, publishers, museum curators and librarians who, with gracious willingness, gave permission to use pertinent material. We express our particular thanks to Betty Kingston, Librarian of the Chinese Collection in the Royal Ontario Museum, Toronto, and to Mrs. Margaret E. Parkin in the Cleveland Museum of Art. These friends were more than kind

to us in our search for footprints that would lead in the direction of Wang Wei.

For correspondence with and consultation we wish to thank the following: Chang Dai-ch'ien, San Paola, Brazil; Fei Ch'eng-wu, London; Basil Gray, Keeper, Department of Oriental Antiquities, British Museum, London; Clifford C. Gregg, Director, Chicago Natural History Museum; Wai-kam Ho, Assistant Curator of Oriental Art, The Cleveland Museum of Art; Sherman E. Lee, Director and Curator of Oriental Art, The Cleveland Museum of Art; Chu-tsing Li, Assistant Professor, University of Iowa; Agnes E. Meyer, Mount Kisco, New York; Jack V. Sewell, Curator of Oriental Art, The Art Institute of Chicago.

WE ARE GRATEFUL for permission to quote from these publications: Harry N. Abrams, New York, for Lee's *A History of Far Eastern Art*; Ernest Benn, Ltd., London, for Waley's *An Introduction to the Study of Chinese Painting*; Bollingen Foundation, New York, for Mai-mai Sze's *The Tao of Painting*; Coward-McCann Inc., New York, for de Reincourt's *The Soul of China*; Harvard Journal of Asiatic Studies, Cambridge, for Pope's *The Art Tradition*; Harvard University Press, Cambridge, for Hung's *Tu Fu, China's Greatest Poet*; Houghton Mifflin Co., Boston, for Florence Ayscough's *Tu Fu the Autobiography of a Chinese Poet*; Percy Lund Humphreys & Co., London, for Siren's *Chinese Painting*; John Murray, London, for Sakanishi's *An Essay on Landscape Painting*; also, *The Spirit of the Brush*; Oxford University Press, London, for Saunders' *A Pageant of Asia*; Phaidon Press, Ltd., London, for Cohn's *Chinese Painting*; Princeton University Press, Princeton, for Rowley's *Principles of Chinese Painting*; Sidgwick & Jackson, Ltd., London, for Jenyns' *A Background to Chinese Painting*; Charles E. Tuttle Co., Ltd., Rutland and Tokyo, for Munsterberg's *The Landscape Painting of China and Japan*; also, for van Briessen's *The Way of the Brush*; University of California Press, Berkeley, for Sullivan's *An*

Introduction to Chinese Painting; University of Chicago Press, Chicago, for Ferguson's *Chinese Painting*; Viking Press, Inc., New York, for Fei Ch'eng-wu's *Brush Drawing in the Chinese Manner*.

WE THANK the various museums and collectors who have graciously given permission to use photographs from their collections: Abe Collection, Osaka Museum, Japan for *The Old Scholar Fu Shêng Engaged in Restoring the Text of the Shu Ching*; Chang Dai-ch'ien, Brazil, for *Interpretation of Poem by Wang Wei* painted by Tung Ch'i-ch'ang; Director of the Museum, Si-an, for rubbings from stone engravings of *Bamboo* after Wang Wei; Freer Gallery of Art, Smithsonian Institution, Washington, D.C., for *The Nymph of the Lo River*; Museum of Fine Arts, Boston, for *Female Polo Player*; University Museum, Philadelphia, for *Relief from Tomb of Emperor T'ang T'ai Tsung*; for *Clearing After Snowfall on the Mountain Along the River,* the Honolulu Academy of Arts, Honolulu; the Fogg Art Museum, Harvard University, Cambridge; Ogawa Collection, Kyoto, Japan; the Royal Ontario Museum, Toronto, for Tomb Tile Photographs; for *Wang Ch'uan Scroll,* The British Museum; the Chicago Natural History Museum (photograph of rubbing from stone engraving); Harvard-Yenching Library, Harvard University, Cambridge; Professors Kobayashi and Kaizuka, Kyoto, Japan; and the Seattle Art Museum, Seattle.

THIS BOOK has been published with the assistance of a grant for research from the University of Toronto.

INTRODUCTION

IT HAS BEEN only in the twentieth century that Western students of oriental culture have begun to discover values resident in Chinese painting. With this discovery has grown an increasing appreciation on the part of scholars, connoisseurs and collectors, and surprisingly, by the general public of Chinese art. As a result of this an unusual number of books, finely illustrated, has appeared in the past few years. These deal mainly with broad surveys, distinctive techniques and histories of Chinese painting, or else with special forms of oriental art work—ceramics, bronzes, lacquers, and so on. Now, we believe, the enthusiasts are ready to welcome monographs on individual Chinese artists.

With this thought in mind, the present volume is offered. The choice of Wang Wei is an appropriate one. This eighth century genius—artist, poet, musician, doctor and official—lived when the most brilliant cultural period in Chinese history was at its crest. His most creative years coincided with the cultural climax of the T'ang Dynasty.

Wang Wei was a notable exception to the rule, "A tinker of all trades is master of none." He exhibited a versatility equal to that of the great Italian, Leonardo da Vinci. Whatever he attempted, he performed with a master's touch. As a poet, he earned the title of "Great." He is acknowledged as the father of pure landscape

painting destined to become classic throughout the world. Wang's initiative in monochromes and his advanced skill in method were harbingers of different types of painting. His genius rose above the limitations imposed by environment to a height where he could feel more acutely than others, sing more truly, and paint more clearly those intuitions derived from religious meditation and communion with nature.

We have placed considerable emphasis on the political, social and cultural background of Wang Wei's life. Genius though he most certainly was, Wang could not escape the formative impact of T'ang times. No man can avoid the influence of the sources from which his very life-stream emerges. Consider the eighteenth century in the West, so strongly stamped by a sense of security, cushioned with the clear-cut conviction of right and wrong, blessed by the certain knowledge of the existence of God—this confidence coloured much of the creative effort of that period. In France, Fragonards and Watteaus depicted the romantic life of the nobility; in Britain, Romney and Reynolds put portraits of proud "self-made" business tycoons on canvas.

Our own time has seen the complacency of the eighteenth century shattered by the disillusionment of two world wars and exhausted by the suicidal conflict of the Cold War. Instead of the certainty of a century ago a new, pervasive doubt haunts our minds. Former ethical and religious concepts are questioned. People are asking, "What is truth?" "Is God dead?" Or they boldly assert without much challenge, "There is no God." And so artists with frenetic zeal try to show the meaninglessness of life—with often meaningless pictures.

Thanks to the T'ang Dynasty atmosphere of Confucian confidence, Wang Wei enjoyed a security resembling that of the eighteenth century in the West. What was right and what was wrong had been minutely detailed by Confucius. Philosophy had placed man as an individual entity of the great cosmos, belonging

as much to nature as a mountain or a flower and with his own predetermined place and part. Furthermore, Wang was fully aware that he belonged to the powerful Middle Kingdom, the centre of the then-known world—the most advanced Empire which had ever existed until that date. His period was not one of introspective probing; his problems were mainly objective.

This story of a great man and his work, who lived in a period of history long before the New World had even produced a history, is simply presented; however, care has been taken not to deviate from historical accuracy. Modern psychiatry has revealed that we learn almost as much about humanity from legends as from historical reports. With this in mind some folklore typical of Wang Wei's time has been included—partly to add colour—not of course to be taken literally.

LIFE IN T'ANG CHINA

THE GOLDEN AGE

THE ASCENDANT YEARS of the T'ang Dynasty (618–906) shine as an era of unparalleled brilliance. The Imperial Court, as had earlier courts, nourished talent in a luxurious environment, cost-free and care-free. And who can say that the painter-poet-musician, Wang Wei, would have left imperishable proofs of his genius had he not been born within this era? Had he never participated in the exchange of inspiration with other gifted minds?

This period of Chinese history can fairly be compared with the Age of Pericles in Greece when, it is reported, twelve of the world's greatest brushed elbows in the streets of Athens; or with sixteenth-century Italy, when Michelangelo, Leonardo da Vinci, Raphael and Botticelli were well acquainted with one another's work if not with each other.

Yet in no other country have artists been required to undergo a preparatory discipline as difficult as that demanded in China. In few civilizations—and never for hundreds of continuous decades —have the talented been so conditioned to one fixed route to recognition. Recognition depended in most cases upon two accomplishments: first, passing final competitive examinations of inexorable exigency; and then receiving official economic pa-

tronage. Thousands failed each time. From the few who survived sprang most of the astonishing creative harvest which has immortalized Chinese painters and poets throughout the ages.

Nevertheless, the achievement of recognition was not sufficient to insure an artist's success. In Chinese thinking, the artist requires stature to the degree of his felicity in expressing the *Tao*, or the Way, the cosmic law of nature underlying all religion and philosophy. Therefore the master painter, however gifted, cannot use his perfected technique for self-expression alone. He must also be able to reveal the vital essence of his racial heritage embedded deep in the matrix of his own unique culture. To do this, he must have profound observation, a consciousness of history and a philosophy both pragmatic and spiritual. As Laurence Binyon says, "The deepest intuitions of the race are deposited in its art."[1]

CH'ANG-AN

THERE WERE TWO capitals of China during the T'ang Dynasty, one hundred miles apart: Lo-yang, the eastern and Ch'ang-an, the western. Both equally imposing at the time of Wang Wei, Ch'ang-an, "City of Eternal Peace," was by far the more dazzling. For here Hsüan Tsung (713–756), generally known as Ming Huang, "Brilliant Emperor," resided the larger part of the year surrounded by the most enlightened court in the Eastern World. A true connoisseur, he collected the choicest talents in his realm. Several of China's celebrated artists, Wang Wei among them, worked together in the capital. With frescoes and large paintings —all masterpieces—they embellished the royal palaces and temples. Likewise there, her finest contemporary poets[2] sang their songs out of the deep joy or tragedy which filled their sensitive souls.

20 Many travellers migrated to Ch'ang-an from the South, East

and West: Greeks, Persians, Arabs, Turks, Syrians, Koreans, Japanese, Tonkinese, all appeared to live together amicably. Various motives impelled them to seek out that far-off exotic land. At least ten embassies journeyed from Islamic Persia between 713 and 750 to establish trade and later diplomatic relations. Their expeditions were frequently accompanied by troupes of gay dancers and brought with them fiery, thoroughbred horses. Merchants hoped to fulfill their dreams of quickly acquiring fabulous fortunes. They had heard of the rare treasures created by Chinese ingenuity, patience and industry, the like to be found nowhere else. The religious-minded, escaping persecution in Western countries, met in Ch'ang-an with a relaxed tolerance. And students were drawn by rumors of strange oriental philosophies which might add rare nuggets to their eternal mining for truth. More than five thousand scholars from foreign countries are said to have studied in the capital at one time during this era.

All descriptions of Ch'ang-an picture a metropolis of surpassing beauty. Each of the three imperial palaces comprised virtually a city in itself, filled with pavilions, temples and audience chambers. Each had its own court and coterie of attendants. Secluded within its own high walls, each palace was crowned with turrets and towers which looked down upon a maze of courtyards and colonnades—enough to confuse the imagination.

Private covered walks connected all the palaces. One passageway led from the "Palace of Expanding Joyfulness"[3] to the "Hibiscus Gardens" in the southeast corner of the city wall by the "Curving River." At this very popular pleasure park, especially in spring, thousands of prospective scholar-officials congregated for the celebrations following their final examinations.

In the palace grounds, marble bridges with delicately carved balustrades crossed crystal streams and artificial lakes in which floated graceful swans while ducks chased fish. Peach and pear trees intermingled with trellises of wistaria vines and climbing

21

roses edged quiet pools flaked by drifting cassia petals. Black-spired cypresses stood like exclamation points by rockeries dotted with dwarfed trees. Weeping willows decked the large courtyards, also tall straight poplars whose leaves turned silver in the wind. Autumn made a glory of the *wu-t'ung*[4] trees—first yellow, then russet brown.

Within the palace gates, the salons and apartments displayed almost unbelievable grandeur. Both ceilings and supporting pillars glistened with gold and vermillion lacquer. Richly carved furniture—chairs, chests, couches—sparkled with inlaid mother-of-pearl and semi-precious stones. Concealing the inner halls and chambers, silk curtains swayed with the breeze or hung motionless, weighted down with embroideries of pearls, rubies, jades and sapphires. One audience hall overpowered the eye by a display of seven enormous frescoes.

Animating these exotic settings, specially chosen maidens arrayed as luxuriously as their surroundings waited in hushed attendance or glided silently on their missions.

The oldest of the royal residences, "Palace of the Supreme Principle,"[5] rambled along the northern city wall. Emperors had lived here since the beginning of the Dynasty. Within its confines were hidden not only extravagant apartments for the Sovereign and his family, but for his large harem as well.

All official ceremonies and rites took place in this palace. Along its southern wall ran the Imperial City,[6] an enclosure about equal in size. This complex of buildings housed all Government offices where administrative functions were discharged.

Because of the heat in the low level of the area, Emperor T'ai Tsung began the construction, in 634, of a more salubrious palace on higher ground to the northeast, outside and abutting the city wall. This was the "Palace of Great Brilliance."[7] Its extensive grounds provided space for most of the royal entertainments. Within the palace walls was situated the Han Lin Yüan, China's

CITY PLAN OF TANG DYNASTY CHANGAN

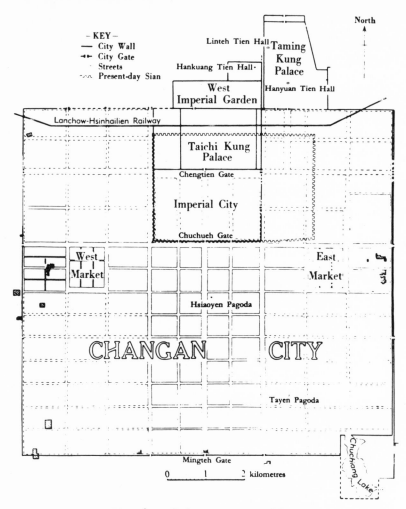

- KEY -
— City Wall
◄► City Gate
··· Streets
~~ Present-day Sian

Linteh Tien Hall
Taming Kung Palace
Hankuang Tien Hall·
West Imperial Garden
Hanyuan Tien Hall

North

Lanchow-Hsinhailien Railway

Taichi Kung Palace

Chengtien Gate

Imperial City

Chuchueh Gate

West Market

East Market

Hsiaoyen Pagoda

CHANGAN CITY

Tayen Pagoda

Mingteh Gate

0 1 2 kilometres

Chuchiang Lake

2. City plan of T'ang Dynasty Ch'ang-an.

famous Imperial Academy. A small pavilion housed the "Pear Garden Conservatory,"[8] an academy of music and dancing. Within the grounds the Emperor, with true filial piety, erected a tower[9]

23

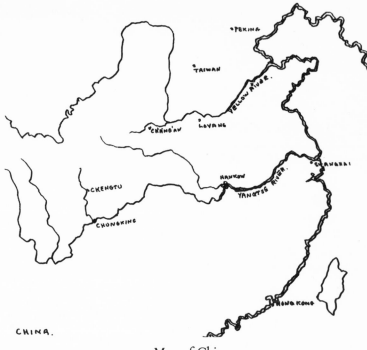

CHINA.

3. Map of China.

for the benefit of his aged father who had abdicated. Here on fine days his revered parent could be carried in comfort to gaze out over vast distances in all directions.

Roughly the circumference of the whole capital, a royal hunting preserve ran along the northern wall of the city and stretched far beyond it.

The Palace of Great Brilliance was destined, like the cathedrals of Europe, to take more than one lifetime to complete. Upon his father's demise, Emperor T'ai Tsung dropped the great enterprise and the structure lay deserted until 662, when Emperor Kao Tsung repaired and extended it.

Recent archaeological excavations disclose the foundations of this palace to be immense even by today's standards—approxi-

mately one and one-third miles by one mile, "with ten courtyards, twenty-one gates, and twenty-four smaller palaces connected with it."[10] The wall of the main palace was about five miles in length and in places forty feet thick. In the throne room, the platform, eight feet high, measured about 425 by 230 feet.[11]

Wang Wei describes a frequent scene:

> The nine "gates of heaven" swing open on the palace courts within;
> Worshipping officials from ten thousand countries kneel before
> the imperial insignia.[12]

On ascending the Dragon Throne, Ming Huang built another complex already mentioned—the Palace of Expanding Joyfulness. It was placed by the eastern wall of the capital to the right of the Imperial City. The Sovereign had never lost his nostalgia for this area since, as a youth along with four princely comrades, he had lazed away much of his happy, carefree time here. When these palaces were completed (726–728) most of the Court was moved there from the Imperial City.

Inside the compound of the Palace of Expanding Joyfulness, to the northwest stood the "Pavilion of Perfect Harmony."[13] On the walls of this pavilion, Wu Tao-tzŭ, the renowned contemporary of Wang Wei, astonished his world by painting in a single day the hundred miles of the Chia Ling River in Szechwan. Ming Huang had sent Wu to that far away province to fix in paint the unforgettable scenery of this branch of the Yangtse at Chungking. Months later Wu returned—without a single picture. The Emperor scowled with indignation.

"But your Majesty," Wu tremblingly explained, "I have it all in my head."

Fortunately for the artist, he had.

Earlier, Li Ssŭ-hsün, the first of the court painters, presumably laboured for all of three months to paint the same river. To save Li's face, Ming Huang diplomatically pronounced: "Wu's

25

painting of a single day and Li's painting of three months are both masterpieces."

That Li Ssŭ-hsün died in 716 and that the pavilion was not even completed until 728 have never caused this legend to be questioned.[14]

In his private court, directly north of the Pavilion of Perfect Harmony, Ming Huang gave audience both to his guests and officials. Throughout the latter part of his reign, his court was the scene of many elaborate festivals, processions and pageants.

Scattered in and about Ch'ang-an, numerous noteworthy temples paid homage to religion. In one, the "Auspicious Cloud Temple,"[15] Wu Tao-tzǔ pictured the Buddhist "Tortures of Hell" so realistically that the hair of every beholder stood on end. Even among the lowest class, the butchers and fishmongers thoroughly accustomed to killing, dropped their trades in terror, to hunt for jobs more acceptable to Heaven.[16]

A custom in the memory of living Chinese, still practised around the turn of this century, may have stemmed from this method of instilling horror of hell-fire. In the small towns and villages of Shantung, every three years, religious festivals drew the attendance of apprehensive peasants from miles around. On these occasions, large charts advertising the future punishments for all types of sinners, frowned menacingly from the balconies of the temple courtyards. How the impressionable soul must have shivered—particularly the merchant who cheated on weight, always pictured suspended from the hook of a steel-yard clasped tightly around his spine. The temples in the larger cities displayed sculptures of the "eighteen hells" of Buddhism, which, being in the round, were still more alarming.

Dotting the plain about Ch'ang-an lie crumbling tombs of eminent ancients, tombs even today distinctive for their size and workmanship. For example, take that of Emperor T'ai Tsung west of the city, commissioned in 637. On six stone panels of

26

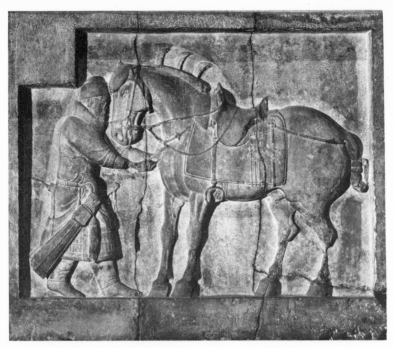

4. "Chestnut Bay Charger," from relief on tomb of Emperor T'ai Tsung, courtesy of the University Museum, Philadelphia.

high bas-relief, his famous spirited chargers[17] more than five feet tall formerly mourned their master in the walls of the fore-temple where Wang Wei would often have admired them. Now, two of these priceless treasures are in the Philadelphia University Museum; the others add to the prestige of the National Museum in modern Si-an, the approximate site of ancient Ch'ang-an.

Thirty miles east of Ch'ang-an, a pleasure resort "Warm Springs,"[18] lay nestled in a superb setting against the side of Li Mountain. Wang Wei frequently passed through this village during his early life. He may even have joined in the royal revelry there.

Long after, in 1936, Generalissimo Chiang K'ai-shek briefly

27

established his headquarters in Warm Springs. He had flown to the Northwest to bolster the morale of those weaker officers advocating cooperation with the Communists against the Japanese invaders. In 1957, I was shown his quarters, and the back wall over which he fled from insubordinate underlings to the small mountain pavilion where he finally surrendered.

Notorious for some thousand years of wildly extravagant celebrations ordered by merry-making monarchs, Warm Springs is today a vacation centre, though now for the proletariat. What all-powerful occupant of the Dragon Throne could ever have dreamed that future generations of his lowly subjects would dare touch foot to this ground sacred to royalty!

Not far beyond Warm Springs rises a tremendous tumulus larger than the biggest pyramid in Egypt. Here is concealed the mausoleum of the Emperor who founded the Ch'in Dynasty (B.C. 221–207). According to legend, the ceiling glitters with stars above rivers of quicksilver which flow along the great map of China inlaid upon the bronze floor.

I climbed this monumental mound. The weather-beaten slopes worn smooth with time, there it still stands, silently recalling history of long ago, still impressive after two milleniums:

> The plaintive music of the wind in the pines
> Sighs as if his noblemen still mourned him there.[19]

THE EARLY EMPERORS

THE EARLY T'ANG EMPERORS progressively laid the foundations for the magnificence of the Dynasty which achieved its zenith in Wang Wei's day. Their energy expressed in the architectural glories already described, also encompassed broad thinking. Chinese women in society enjoyed a freedom unknown before

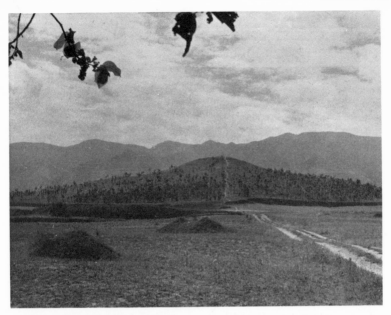

5. The grave of Ch'in Shih Huang Ti. Photograph taken in 1957 by Lewis C. Walmsley.

the T'ang Dynasty, a freedom never retrieved until modern times. The long-enduring fashion of bound feet did not hold them captive, physically or mentally, until toward the end of the T'ang. Men and women often rode horseback together and royal ladies accompanied the noblemen even in the hunt, riding astride at that —a custom verified in the Royal Ontario Museum, Toronto, by figurines taken from T'ang graves. At the capital, the prevalence of tribesmen from the northwestern borders, with novel ideas which were quickly assimilated, is given partial credit for gaining this temporary emancipation of Chinese women. The T'ang leaders in turn mixed freely with these "barbarians" who were fascinated with the unfamiliar high standard of central China's culture.

The second T'ang Emperor, T'ai Tsung (627–649), had solidi-

29

fied the Empire even during his father's occupancy of the throne. T'ai Tsung's character embodied the full strength of Confucian morality, a noble example to his people. He expanded mental horizons by a sweeping tolerance of all the various religious faiths then beginning to penetrate the country from far-off lands— among them Nestorian, Manichaean, Mohammedan, the Persian Zoroastrian worship, and the Syrian Jewish belief.

"Religions have many names," the Emperor maintained. "There have been many wise men and even if their teachings differ, they can be a blessing to mankind."

Buddhism, originally from India, was at the height of power then, although the majority of the Chinese people never completely abandoned their beliefs in Taoism and Confucianism. Except for Buddhism, other foreign religions, though tolerated, made little impact.

The most dominant ruler of the half-century previous to Wang Wei was a woman, unequalled in statecraft and in female ferocity. Empress Wu Chao was still living in 701 when the artist was born. In spite of preoccupation with ruthless intrigues, in spite of blood baths which almost liquidated the royal house of T'ang, she continued assiduously to furnish the stage for the coming cultural renaissance. Under her, for some fifteen years, the country enjoyed a rare freedom from border wars and international entanglements; providing the prosperity and leisure necessary for creative enterprise. She commissioned large frescoes to adorn the magnificent temples, and monumental sculptures to focus attention on sacred shrines.

Wu Chao must have been born under the most favourable astrological confluences. Her story reads like a novel. Her father, a high ranking commander of great wealth, had helped to found the Empire. T'ai Tsung paid him the unusual honour of a visit and the further honour of inviting him to send his young daughter, a budding adolescent of fourteen, to join the royal harem. Accord-

30

ing to one legend, her mother wept at this fate—but not her child. Proud to belong to the Son of Heaven, the little new concubine so delighted her master that he called her Seductive Wu. A born opportunist, she made it a point to please the Empress as well with a flattering adoration. Her utter lack of fear, her high spirits, her talent for literature and her vaulting ambition promised rapid promotion. Yet oddly enough, she remained in the lowest rank and when, ten years later, T'ai Tsung died, her dreams of attaining royal status died with him. All his concubines, their heads shaved, were banished to the barren cells of Buddhist convents to become nuns.

A most extraordinary intervention saved her from this unlikely career. Ever since puberty, the former Crown Prince, now Emperor Kao Tsung (650–683), had had a wandering eye. For some time he had fixed it on only one maiden—Pure Concubine. His Empress felt deeply humiliated. A harem had doubtless conditioned her to the idea of safety in numbers; but just one rival was not to be endured. To stop this, she invented an amazingly naive plot. She would expose her erring spouse to a superior charmer— but where? To whom could she turn? Wu Chao, of course! Had she not been generally conceded to be the most ravishing enchantress alive? And having won him, Wu would naturally transfer his affections to their rightful owner if only out of gratitude to her adored Empress.

This proposition thrilled Wu Chao. Her own eye had long been fixed on the Crown Prince and, humble as her position had been, she had reason to believe he was not entirely indifferent to her. She went to work with a will and soon ensnared him beyond redemption. He could deny her nothing, first through his unbridled passion and later through stark fear of her.

Wu Chao managed to displace the Empress completely—and then the tigress unsheathed her claws. Under false accusations, she imprisoned the Empress and Pure Concubine. Later she ordered

31

their hands and feet chopped off and the bodies thrown into a brewing vat.

After this, Wu Chao virtually ruled the Empire. From then on she ruthlessly killed anyone who got in her way. Yet her impersonal judgments were clear and uncomplicated and she displayed masterful diplomacy in guiding affairs of state. Several times she upset the chosen line of royal succession in order to establish her own Dynasty, the Chou, which she actually did in 690. At the same time she assumed the title of "Emperor"—the only woman emperor in Chinese history.

A few months before becoming Emperor, she issued an edict that she, herself, was the reincarnation of the Maitreya Buddha. Already devoted to Buddhism, her interest now amounted to an obsession and she filled its coffers with untold treasure.

Wu Chao lived to be more than eighty years old. Her last years were plagued by illness and by palace intrigue. The Chou Dynasty was overthrown; but not until five years after her death did the rightful T'ang heir, Ming Huang, mount the T'ang Dragon Throne—a grandson of Emperor Kao Tsung.

At the time Wu Chao entered the palace, it seemed unlikely that the T'ang Dynasty would survive the death of T'ai Tsung because the unity of the Empire was so recent. Now, after fifty years of a woman's autocratic rule, China found herself more united, more powerful and more wealthy than ever before with her boundaries vastly extended.

The Golden Age of Chinese culture was brought to fruition in the reign of Ming Huang.

Twenty-seven years old when his reign began, Ming Huang was suave, imaginative, musical and scholarly. He worked conscientiously for the good of his people for thirty years. Sometimes his preoccupation with the public welfare led him to excesses of frugality with his Court. He not only frowned upon all signs of luxurious living but promptly extirpated them. At huge public

demonstrations for economy's sake, roaring bonfires melted down rich ornaments and dissolved brocades stiff with gold and silver embroidery. Not even the royal robes of his Empress were exempt. He forced her to appear publicly clad in shoddy clothing anything but regal.

Population in the T'ang Dynasty was small, around fifty million. Land distribution was generous; taxes light. To help the peasants further, and to "harmonize" the economic structure, the Government purchased grain at higher than market price in years of good harvest and sold it well below when famine threatened.

Nevertheless, the Government revenues on grain and varieties of silk yielded enormous returns. The Emperor introduced far-reaching reforms and he revised the educational system, multiplying the schools. An official communication system spread a great network to the farthest corners of the Empire. After the adoption of a revised criminal code, banditry soon virtually vanished and other crimes diminished drastically.

In spite of his penury toward the Court, Ming Huang carried to its apex the cultural tradition of the T'ang rulers, gracing it with the most able brains and most gifted artists in the Empire. Among these was Wang Wei, who held at different times several other official titles.

When pressure from Ming Huang's arduous duties permitted, his preferred recreation lay in the sparkling give-and-take of wide-ranging discussions common to scholars and artists alike. This transfusion of the blood of the intellect was bound to nourish creative power. Such exchange of ideas, ideals and philosophies helped to father one of the rare moments in history when Mother Nature gives birth to genius with prodigal lavishness.

Left to themselves, scholars enjoyed a variety of entertainment: gathering in tea houses or wine shops to match wits and quaff wine; "capping" verses with a skill demanding both versatility in semantics and familiarity with the classics; exhibiting prodigious

33

feats of memory instilled by the repetitive training for the Imperial Examinations; writing poetry or painting brief sketches; and singing, improvising or performing music. Such artistic acrobatics occupied many a leisure hour.

A favourite game might well have been made the subject for a painting. Imagine several scholars in satin skull caps, their long silk gowns brightly embroidered, seated on stools of stone or lacquered wood around a charming lotus pool. A tray furnished with a lighted candle, ink-pan and ink, brush and paper is pushed into the water. Wherever the tray touches the bank, the nearest player must seize it and dash off a verse or a drawing before the tiny glimmer goes out. Fail? He pays a forfeit.

Athletics, as we know them, were rare. Few sports called for strenuous activity, nor were they needed for physical fitness. The minimum daily requirements of existence—keeping fed, keeping warm, keeping clean—kept muscles hard. Strolling formed a popular pastime. Indeed all but the highly placed made any journey on foot, frequently the only means of transportation. An attendant usually carried essentials of clothing and bedding on his back. Archery contests provided both fun and training for hunting and warfare.

The importation of thousands of spirited horses from the West, including the novelty of tall steeds from Turkestan, captured the interest of royal courtiers as a chief attraction. Some nobles engaged in polo, a sport only recently introduced from Central Asia. Others hunted, often with falcons tied to their wrists. For those unskilled in polo or hunting, riding for pleasure became their main recreation. Ming Huang's stables purportedly harboured forty thousand thoroughbreds, a number to stagger the imagination. Painters and sculptors often turned the stalls into temporary studios. One Han Kan, sponsored by Wang Wei, is said to have persuaded the Emperor that access to these magnificent animals was the only instruction a painter needed.

34

6. "Female Polo Player," T'ang Dynasty pottery, courtesy of the Museum of Fine Arts.

With the encroachment of middle age, an astonishing side of the Emperor's nature emerged. According to rumours, mental disturbance caused his model character to deteriorate. It seems more likely that long repression and endless dreary routine suddenly awoke him to his fleeting years. Or perhaps he recalled that Chinese proverb: "Enjoy yourself, it's later than you think." Whatever the reason, from his former extreme asceticism he became a complete hedonist and suddenly threw himself wholeheartedly into the lures of an extensive harem. For the rest of his reign, he left the affairs of state almost entirely in the hands of ministers, too frequently as indifferent to the welfare of his people as was their master now. The extravagant saturnalia that followed had never before been equalled.

Annually in the tenth month, the Emperor always visited the "Palace of Splendour and Purity" at Warm Springs—an excursion formerly invested with strict austerity. In contrast now, his

35

royal processional was crowded by "carts of cronies like streams and valleys," and so overloaded with gems that the wheels ground down masses of dropped pearls, bits of jade, precious stones, jewelled hairpins and pretty slippers. After the parade had passed, the peasants descended like hungry vultures, fighting one another to retrieve what they could from this windfall.

When Ming Huang was fifty-one, his favourite concubine died. All gaiety ceased while, for two years, he refused to be reconciled. Desperate with living under a lovelorn monarch, the courtiers hunted far and near for someone to replace her. They found one irresistible enchantress—none other than his own daughter-in-law, wife of his eighteenth son, Prince Shou. No one questioned Ming Huang's right to possess her, not even his son. The Emperor's will was supreme, his word life or death.

Yang Kuei-fei, soon Imperial Concubine, is known in history as China's most famous courtesan. She is more celebrated in poetry and song than any other Chinese woman. The paragon of imperial prestige, she personified the T'ang ideal of sensuous beauty.

What was her real appearance? Other eras, other tastes. In 1957, I saw replicas of her in the Si-an Museum. Her figure was appallingly plump—just the opposite of her counterpart, the seductive Flying Swallow in the Han Dynasty who was "tiny enough to dance on a man's hand."

Yet no concubine before, not even Flying Swallow, was ever so indulged as Yang Kuei-fei. Near his own quarters in the Palace of Expanding Joyfulness, to the right of the reflecting "Dragon Pool," Ming Huang took the unheard-of step of ordering for her a magnificent palace. The "Pavilion of Lign-Aloes"[20] required seven hundred workers to carve it. Several hundred more risked their eyesight decorating it with the finest weaving and most intricate embroidery.

The Emperor seems to have lost all his former solid Confucian

sense of propriety for now he exceeded this wild extravagance by giving each of Kuei-fei's lovely sisters a palace apiece. He conferred noble titles on them and an enormous stipend, including one million cash for cosmetics alone.[21] Prior to this (except for princes) none but princesses had been pampered with personal courts and officers of rank. Later, Ming Huang abolished these personal courts after their power led to treacherous uprisings; or perhaps because he had too many daughters among his fifty-nine children. Uprooted, the surplus princesses now lost their identity by being married off, usually to noted scholars. Like all wives of commoners, each now was forced to accept the role of traditional loyal servant to her husband and his parents.

Ming Huang did not neglect this concubine's male relatives. Undeserving though they were, they all received high ranking positions. Soon five different Yang families, each with its personal liveried retinue, could be seen haughtily parading the streets of Ch'ang-an.

Toward the end of Ming Huang's reign, great injustices aggravated already intolerable conditions. Costly burdens of the licentious court brought starvation to the Empire: Consider that for one morning's performance, the royal orchestra received three million cash.[22] When Yang Kuei-fei suffered a bad toothache, an advisor who suggested a remedy was rewarded with twenty pounds of gold, three thousand loads of rice and thirty rolls of cloth. The example of the royal household infiltrated the upper classes like a poisonous miasma; local officials, hoping to obtain royal favour, risked bankruptcy to emulate such mad spending. Rank was conferred on informers who spied on their neighbours —one such, a humble cakeseller, strutted about as a general! People dared not speak out, so spoke words with double meanings.

In the early 750's, palace intrigue erupted in rebellion. It was headed by an army officer, An Lu-shan, a young ambitious soldier of fortune reported to be enamoured of Yang Kuei-fei. Although

37

with the violent blood of barbarians in his veins, this adventurer was extraordinarily intelligent. Without arousing suspicion of his penchant for the favourite, he had managed to insinuate himself into the graces of the Monarch. Doubtless Yang Kuei-fei aided him—she adopted him as her "son,"—of course with the Emperor's permission. A "birthday" party honoured the impostor, who, clad as a baby in diapers, was wheeled about the palace. Much amused, the Son of Heaven bestowed upon the baby a bath present of about ten thousand "dollars".

When An Lu-shan felt strongly enough entrenched, he dared the treason long plotted in secret—to seize the throne and hopefully Yang Kuei-fei with it. In 755, his forces captured Lo-yang and threatened Ch'ang-an. The Emperor and his entourage fled. En route to Szechwan, Ming Huang's own officers defected but offered him freedom in return for the life of Yang Kuei-fei. Self-preservation won. Before a Buddhist shrine at the little town of Ma Wei, Yang Kuei-fei was either strangled, or was permitted to strangle herself.

Ming Huang continued his flight to Szechwan where he remained until peace was restored. In the meantime, while he was still a refugee from the capital, his son Su Tsung, proclaimed himself ruler. In 756, Ch'ang-an fell to the rebels. The war had so decimated the population that history records as surviving only about seventeen million of the approximate original fifty million.[23]

An Lu-shan's oppressive rule soon evaporated, and within a year his own adopted son is reported to have murdered him. Emperor Su Tsung then returned to the capital. His aged father delayed until the last of the insurrection was permanently put down.

Only one objective in life remained to Ming Huang—his beloved Yang Kuei-fei must be restored to him from the other world. He dispatched one delegation a thousand miles and another as far as India to collect precious herbs presumably possessing supernatural properties. He firmly believed that Yang Kuei-fei

was waiting for him but immobilized until magic could release her.

In spite of the misdeeds and disasters of Ming Huang's last years, his subjects always remembered him with affection. They did not forget the thirty good years of his early devotion to them, during which he had maintained peace, spread prosperity and secured the Golden Age of Chinese culture.

RELIGION IN T'ANG CHINA

THE OFFICIAL CODE of morality implanted by the Confucianists had taken deep root among the masses of China. Although adhered to more lightly among the ranks of the higher nobility, this ethical system had a strong stabilizing effect upon the educated who, after all—perhaps until Communism—have always set standards for the proletariat. The curriculum for the scholar class was based upon works edited by Confucius, and reinforced by rigid commentaries. Tradition had moulded an "ism" about the teachings of this genius, an "ism" more of a strait-jacket than any word picture could possibly convey.

Confucianism fused into a system of ethics those principles that trial and error had shown best suited to the Chinese way of life. It clarified values in no uncertain terms and with no fuzzy edges. It defined explicitly points of deportment, family and social relationships, duties of the lower classes of society, responsibilities of the higher. It offered the ideal of the "princely man," and outlined rules of filial conduct and ancestor worship. It specified the appropriate in human relationships in such detail that no doubt whatever was left as to what was done and what not done among the millions of families who shared the "four hundred names," or surnames common to all of China.

But Confucianism stopped there. Scarcely a religion, this prag-

39

matic arrangement of rules offered virtually neither philosophy nor courage for the every day struggle and little hope for a future existence. Nevertheless it was a perfect mortar with which to cement a foundation for building a religious faith. Answers to life's most profound questions must be sought elsewhere.

Unlike Confucianism, Taoism was a religion. It also sprang from indigenous roots far down in the fertile soil of young Chinese culture. The spirit in Taoism more than merely rubbed off upon the character of the common people; it made a brutal life almost bearable. An attitude of acceptance was inherent—patience in adversity, endurance in struggle and the comfort of fatalism in the face of famine or war.

In the Han Dynasty and in the Six Dynasties, Taoism suffered a deviation which degenerated largely into systematized superstition. Now led by wizards and sorcerers, it spawned a seed-bed for swarms of miracle workers eager to compound the magic pill of immortality, and, by alchemy, to turn baser metals into gold. All kinds of charlatans battened on the credulous leanings of the uneducated—and sometimes on those of the educated as well. The rulers themselves fell prey to the hocus-pocus. The most enlightened Emperors, T'ai Tsung, Kao Tsung and, as we know, Ming Huang, all believed in the possibility of immortality through necromancy. The Taoist priests flourished on their own promises of life hereafter, monopolists of this good; and in return they received earthly rewards in position and fabulous sums of money.

There were those whose spiritual needs required something more than either static Confucianism or Taoist superstition. These turned to Buddhism which, by the end of the sixth century, was becoming widely assimilated. Buddhism attracted converts because of its mature philosophy, rich ritual and artistic accomplishments, and also because of its dedicated missionary monkhood. Wang Wei himself adopted this faith, in part because of the intellectual companionship.

40

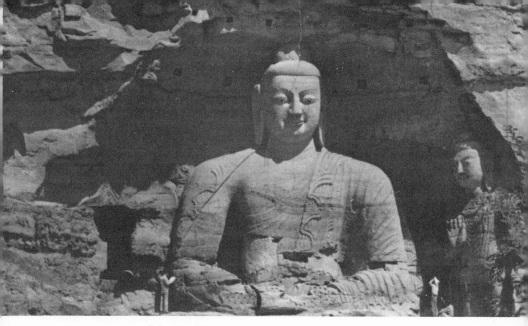

7. Stone image of the Buddha, Grotto 20, Yün Kang Caves, Shensi.

Since he was plagued with a deeply emotional nature, Wang was fated to be constantly frustrated with official life. In later years, he found contentment in other-worldliness, in religion which assuaged his disappointments, and in painting which transmuted them.

Such retreats into the life of the mind and spirit were not unusual among the literati in the T'ang Dynasty. Religion, a common topic for conversation and one conducive of deep discussion, evoked interest in most intellectuals.

Wang Wei seems to have made a working synthesis of these three systems of thought. There is no question as to his fidelity to Confucian moral tradition; scholars are less certain as to which took precedence in his ultimate allegiance—Buddhism or Taoism. Here and there in his poetry we find intimations of Taoist searching:

> *Beside incense tapers I read my Book of Tao.*
> *How quickly I have experienced the deep peace born of quietness!*

41

This contemplative life blesses one with abundance of leisure . . .
Why did you think so seriously of returning?
This worldly life with all its affairs is empty and void.[24]

Do you seek a cure for the disease of old age?
Learn then the Doctrine of the Non-Being—there is only one remedy.[25]

Among Buddhist monks, priests and hermits, Wang found his most fruitful fellowship. He often studied with them in their temple libraries, pouring over priceless literary scrolls nowhere else available. Perhaps to symbolize his closeness to these brothers, he chose a Buddhist name, Mo-chieh, "Untarnished Reputation," after a famous Buddhist Indian saint, Vimalakirti, whose Chinese name was Wei Mo-chieh. In Ch'ang-an alone, an extensive Buddhist priesthood boasted more than sixty temples and twenty-seven convents.

One Buddhist leader who deeply impressed Wang throughout the years was Hui Nêng (d. 715). Wang wrote the inscription for a memorial tablet erected in Hui's honour. Known as the Sixth Buddhist Patriot, Hui started a movement destined to grow into the Ch'an School of Buddhism, better known in the West by its Japanese term, Zen Buddhism. Praising work, it abjured mendicancy and did away with ritual in favour of silence. The goal was illumination rather than credulity and intuition instead of logic.

CULTURE IN T'ANG CHINA

BY THE MIDDLE of the T'ang Dynasty, China had evolved into the cultural and intellectual focus of East Asia. Small streams of creative effort springing centuries earlier were now merging into a mighty current. As the largest, the most prosperous, the most powerful nation in the East she had advanced to a pan-Asian out-

look. Ch'ang-an was renowned as the international centre for the diffusion of Chinese culture. The arts, so royally encouraged, repaid their benefactors with a prestige to be obtained from no other source and assured to posterity an unparalleled pride in the Golden Age of T'ang.

What was the exciting ferment characterizing the environment in which Wang Wei lived? The atmosphere crackled with inventive energy as electric as if sparked by lightning. Take ceramics: factories kept perfecting new glazes; green from copper, blue from cobalt, yellow from iron compounds. The potter through extensive experimentation hit upon the art of making the first porcelain—china—as the West, on discovery, named it. Centuries later, imperial palaces in Europe and the Near East displayed as their prized possessions precious pieces of this Chinese invention, so pure, so chaste, so fragile. For instance, Lord Burleigh, as a very special token of regard for his Sovereign, presented Queen Elizabeth I, in 1588, with a rare Chinese "porringer of white porselyn" garnished with gold. And to expand this Chinese talent, novel designs were introduced from India, Persia, Mesopotamia, Byzantium and Greece. The slow-moving Silk Route, stretching across Central Asia formed a busy bridge to new worlds for new ideas and for profitable exchange of trade.

Forced by the necessity of the times, another revolutionary discovery rocketed China far beyond her neighbours—one eventually with inestimable value for the infant Western nations. This was the invention of printing. Soon access to literature was open to all who could avail themselves of its wealth. This touched off a literary renaissance which resulted in China's first approach to a newspaper; the *Ching Pao,* "Peking Gazette," a Government issue which printed official documents, decrees and memorials. This publication survived for nearly 1200 years.

In 754, Ming Huang reorganized the Imperial Academy established in the reign of T'ai Tsung, naming it the Han Lin Yüan.

43

This Institute of Letters served as the Royal Secretariat until late in the Ch'ing Dynasty (1644–1912). Among various other functions, this office prepared imperial edicts, drafted official documents and edited records for dynastic histories. The outstanding treasure of the Academy was the Imperial Library comprising more than two hundred thousand volumes. Membership in the Academy, a high honour, embraced the most erudite scholars and most accomplished artists of the land. Such famed poets as Li Po and Tu Fu belonged, and Wang Wei was invited on two counts, both as artist and as poet. The Emperor arranged frequent social soirées for the members which blossomed often into most stimulating friendships.

Exclusive to China and financially supported by zealous royal patronage, schools of music and drama were also maturing. These sought out superior ability to be brought to the capital.

The painting produced in this period, as we shall learn later on, reached unprecedented eminence under the guidance of such masters as Wang Wei. In Japan, it aroused ardent enthusiasm for all kinds of Chinese art. Gripped by an almost insatiable thirst for the best Chinese wares, the Japanese emperors sent numerous agents to bring back the finest paintings, bronzes, lacquers and pieces of pottery. The Shōsōin (built around 756) in Nara and the main building of the nearby Hōryūji Monastery still successfully protect these priceless objects of art after all these centuries—by opening them to public view only once a year!

Chinese architecture flourished. The Japanese patterned the ancient imperial palaces in Kyoto after T'ang designs. The Tōshō-daiji still guards the outskirts of Nara, a monument not to Japanese but to T'ang genius. It was begun in 759 by craftsmen imported from China.

A perceptive spirit like Wang Wei's must have been imbued, consciously or unconsciously, with the refinement of taste on every hand. He would be aware of the injection of ideas from

Western ethnic groups whose camel caravans were then bumping along across the Tarim Basin into the Middle Kingdom. He would be fascinated by the new musical instruments and new tunes brought back by Chinese garrisons returning from western outposts flung across the heart of Asia.

Wang must have seen metal workers casting intricate bronze mirrors often ornamented with Greek patterns fresh from the West. These decorations, transformed under Chinese workmanship to express a new realism, became characteristic of the T'ang Dynasty. He must have watched many a sculptor moulding the T'ang horse-and-rider to be placed in the grave for the master's pleasure in the world beyond.

Astonishing examples of incredibly large Buddhist sculpture have survived the centuries. Surely Wang Wei visited the Lungmên grottoes about eight miles south of Lo-yang, those significant shrines carved with a wealth of Buddhist symbolism. Begun soon after 494, by the Wei conquerors who had settled their capital at Lo-yang, these caves sheltered massive figures whose quality of workmanship was surpassed by few such sanctuaries in the world.

In one of these caves, the famous painted Vairocana Rock Buddha was constructed between 672–676. Under the instructions of the insatiable Empress Wu Chao, sculptors chiselled, out of the rock, this image more than forty-five feet high, of realistic violence no doubt pleasing to its violent patron. Although news travelled so slowly, on foot, on horse or on camel, tales of the dazzling splendour of these caves spread throughout the then-known world.

After twelve centuries, the Pagoda of the Great Wild Goose[26] still points heavenwards in the southern suburbs of Si-an, as I saw for myself in 1957. Simple, severe, classic in proportions, its architectural style is immensely pleasing. Engravings in stone after Wu Tao-tzǔ can plainly be seen in the archways above the entrances. Having survived the test of the ages, now its weather-beaten walls

45

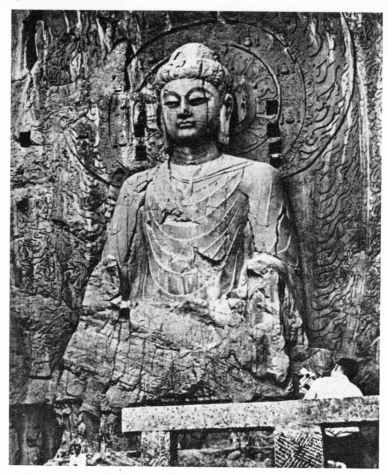

8. Stone image of the Buddha at Lung-men, Honan, height 17.1 metres.

blend harmoniously with the yellow soil of Shensi. To Wang Wei, as to tourists today, this would certainly be one of the sights of the metropolis.

46

LIFE OF WANG WEI
(7O1-761)

THE WANG FAMILY

ACCORDING TO THE FORMER of the two "T'ang Dynastic Histories" (the Old and the New), Wang Wei's life of sixty years began in 701 and is reported to have ended in 760—although a memorial which he presented in person to the throne makes it clear that he was still living in 761!

Wang was born during the reign of Empress Wu in the Year of the Ox under the influence of the element gold. Whether or not his horoscope predicted his future as a planet in the galaxy of artistic stars, family tradition on both sides foreordained him to the highest career open—that of scholar-official in the service of the Emperor. At least four preceding generations of the head of the house of Wang had occupied distinctive administrative posts. His grandfather Wang Chou had received the appointment as one of the Assistant Secretaries of Music in the Imperial Court at the capital, Ch'ang-an.

In turn, young Wang as eldest son was bound to be thrown into the long turbulent stream of heavy disciplines leading toward the essential Imperial Examinations—another "carp aiming to leap

47

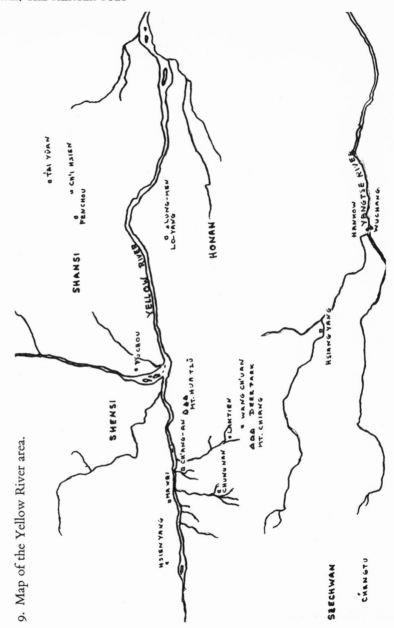

9. Map of the Yellow River area.

through the Dragon Gate," as such applicants were styled. The comparison was apt. To reach spawning grounds up the Yellow River, rainbow carp must hurdle the roaring Wu Men cataracts and conquer the "Dragon Gate," the wild rapids of Lung Mên. Equivalent carp-like qualities of vigour, endurance and persistence were required of students. Out of the million who competed for the first degree, perhaps only one candidate in some fifty thousand[27] would pass the final test.

Why did they try? Because until 1905, when the Imperial Examinations ended, the mighty officials who actually ruled China were chosen from among the victorious scholars. In every Dynasty, despite the omnipotence of the Emperor, brains rather than blue blood commanded awe, respect, reverence—and ran the Government. Yet even without office, such a scholar—the one in fifty thousand who passed—was rewarded with lifelong prestige and social acceptance. And rightly so because the scholars constituted the intelligentsia, bound into a fellowship by subjection to this unparalleled mental discipline.

The T'ang Dynastic Histories outline only the factual skeleton of Wang Wei's life. We can, not withstanding, flesh it out with a fair degree of probability from his own poems, from references to him in other literary works and from the lives of his contemporaries.

Wang Wei's place of birth was Ch'i Hsien, a small town south of T'ai Yüan, which is the present capital of Shansi Province. Shortly after Wang's arrival, his scholar-official father was made Governor of nearby Fen Chou. While Wang Wei was still a child, his father, who had recently moved his young family to P'u Chou, died. This town was much nearer the main current of historic events, situated as it was a little north of the imperial highway connecting the two capitals. Here Wang Wei grew up in the matrix of Chinese history, on the very plains where much of her ancient growth had evolved. Here with Chin, his brother and

49

closest comrade, Wang spent many days of his youth visiting in both Ch'ang-an and Lo-yang. Owing to their distinguished heritage, the boys were always most welcome at Court, particularly among the younger members of the royal family. The palace of Prince Ch'i, the Emperor's brother, was always open to them and here they were exposed to talent of all kinds which the Prince was delighted to foster. Several noble families invited the young men's friendship because of their outstanding charm and their literary and musical attainments.

These brothers apparently never knew the slightest envy of each other. Wang's later poems attest the unbroken affection between them. Chin attained the highest position, that of prime minister to Emperor Tai Tsung, who ruled from 763 to 779. Of three younger brothers, two rose to high Government positions. It is probable that one died early as his name is omitted in all the later records. Of course, no sister is officially chronicled. She would not be considered worthy of mention, unless—against terrific odds—she had made herself eminent as a scholar or notorious as an imperially favoured courtesan. We know only from "Occasional Compositions: Six Poems"[28] that Wang did have a sister; even so slight a reference was rare.

The Wang family apparently enjoyed a very devoted relationship. At sixteen, when absent from home for an important festival, Wang wrote to his brothers:

I am a stranger in a strange land.
On every annual festival, I doubly long for my homefolk.
I think of my far-away brothers climbing the mountains:
Surely they will miss me when they pin on the sprigs of dogwood.[29]

Expression in poetry, like the ability to talk, seems to have been born in Wang Wei—he wrote his first verses at the early age of nine.

Like all small boys, Wang dreamed of a shining future. Here

and there his writings indicate that his obvious ambition was to become the important official his family expected of him. As he grew into manhood, any natural adolescent dreams faded under the weight of Confucian duty. As eldest son, now head of the house of Wang, heavy domestic responsibilities often depressed him, as this touching poem reveals:

> My little sister daily grows into womanhood,
> My brothers have not yet married.
> My family is in poverty—my salary so minute!
> In all my life I have never been able to save one cash.[30]

EDUCATION

WANG WEI'S FORMAL EDUCATION started at about the age of seven. Little Wang probably would go each morning to his classroom in the home. Neatly garbed in miniature cap, coat and gown, a pocket edition of his father, he would dutifully pay his respects to his teacher, then begin work. Perhaps his younger brother Chin accompanied him.

The teacher was likely to be an old friend of the family, highly respected for scholarship and character, but quite possibly one of those unsuccessful in his own attempt to pass the Imperial Examinations. Barred from official position himself, he would eke out a living instructing others. No particular stigma was attached to his failure (paradoxical as this sounds) since, as we have said, so few who started this harrowing race completed the course. Anyone able even to qualify for the final examinations must be a man certainly capable of training the next generation, at least during the first years. Furthermore, this teacher might be preparing in his evenings for still another attempt at these gruelling ordeals. A small sum—three to six "dollars" per pupil per year—would support him. And since his previous failure might have been because

51

he lacked influential friends rather than ability, perhaps between now and the next finals he could make the right contacts. Men as old as fifty years not infrequently reappeared in the great examination halls. Indeed in later Dynasties, grandfathers, fathers and sons have been known to enter together to write the same examination.

These tests were given in the Examination Park, a large, walled enclosure containing row on row of small cubicles each about five feet nine by three feet eight with scarcely room enough for a man to stand erect. Two unadorned boards, one for a table, the other serving both for chair and bed, made plain living and high thinking inevitable. Students successful in the preliminary county and provincial examinations proceeded to the Imperial Capital where every third spring the specially selected students assembled from the length and breadth of the Empire.

And what did they study? In the first years, they built up a fund of information; seasoned timber, as it were, upon which to sandpaper their minds at a later date. The material was clearly outlined and the results to be achieved clearly defined. There was little variation; indeed, the Chinese philosophy of education had, a millenium ago, envisaged a static system of instruction that would create a static society.

Therefore, day in and day out from daylight to dark, seven days a week through continuous chanting, little Wang Wei repeated aloud after the master the sounds associated with the pictographs.[31] He imitated each rising and falling inflection in a high falsetto voice. Thus he stored away in his memory vast quantities of undigested material.

When an assignment was indelibly fixed in his mind, Wang would run to his master's desk, turn his back and as rapidly as possible, parrot-like, repeat the lesson. If he forgot, back to the beginning he would go and start all over again, this time louder and faster than ever, with the hope that somehow his very mo-

mentum would hurdle him over the gap. Mistakes were overcome in much the same way that the old singing master in America would halt the chorister and sounding his pitch-pipe, would send him off on the right note once more.

Very early some practice was given in writing characters. Model strokes and styles were traced with the writing brush on thin paper. This was the beginning of another most exacting discipline, calligraphy. Proficiency in penmanship was a highly appreciated accomplishment, one that demanded a control of brush stroke by muscle perfectly obedient to the will. No one could pass the examinations without having mastered this skill.

For Wang Wei, the painter-to-be, this emphasis on writing was to prove of inestimable value. Every scholar who wished to paint seriously would possess this training in calligraphy as an initial asset. The training given to the perfection of line would ensure a special emphasis on this element in painting. The proficiency in technique would free the artist to express the full force of his emotion in the work at hand.

In 719, at the age of eighteen, Wang Wei took his provincial tests in Ch'ang-an where the tests of the provincial as well as those of the Imperial Government were administrated. He was most anxious to come first not only for the sake of family tradition, but also for the prestige value useful later for the Imperial Examinations. Among his influential friends was that staunch sponsor, Prince Ch'i. Before Wang had "put on his cap" (at twenty) his literary achievements and particularly his dexterity in playing the p'i-pa[32] had won Prince Ch'i's admiration, he, himself, being a competent musician.

A rather dubious legend grew up around this period. As examination time approached, the poet summoned up courage to accost Prince Ch'i. Would His Highness put in a word on his behalf to the Chief Provincial Examiner? Prince Ch'i's brow clouded. Not that the request seemed improper—such favours were often

53

asked—but a highranking princess had already ordered the Chief Examiner to put first the name of the well-known scholar, Chang Chiu-kao.

"What can I do about that?" Prince Ch'i shook his head. "Still —let me think."

Intrigue was second nature to him. Perhaps if the Princess met this attractive young genius? He ordered Wang to practise hard on his *p'i-pa* for the next five days and then bring it to him with ten of his best poems. Mystified, Wang complied. To his amazement, Prince Ch'i draped him in a startling gown and hustled him off to the Princess's palace. Arrived, the Prince addressed the royal lady with due ceremony:

"Since your Royal Highness has always given me the freedom of your palace, I have taken the liberty of ordering for you a surprise party here tonight."

The Princess was delighted.

"And the biggest surprise," he went on, "will be special music played by a special musician."

As the performers entered one by one, the eye of the Princess was quickly caught by Wang who, in his handsome youth and regal attire, carried himself like royalty.

"Is that the one? He looks like a young nobleman. I have not seen him before."

"But you surely have heard of him—Wang Wei? An extraordinary prodigy—as composer, performer and singer."

The Princess immediately requested Wang to sing one of his own compositions. He agreed with engaging modesty and sang with such poignancy that no one could hide the emotion evoked. His song resembled one written later:

> *Love seeds grow in the South*
> *Budding in Spring on every bough.*
> *My friend, gather them recklessly!*
> *They bring me love's fondest memories.*[33]

54

The Princess was dabbing at her eyes. Prince Ch'i pressed his advantage: Wouldn't she like to see more of Wang's work? Without waiting for an answer, he thrust upon her the ten poems so fortuitously tucked inside his sleeve. As she glanced through them she exclaimed, "Ay ah! Students frequently read these. Why, they are supposed to be classics." And to the poet, "Imagine that you —and so young—have composed them!"

At the banquet she placed him farthest from the door which was the seat of honour. Prince Ch'i whispered to her, "What a pity he won't enter for the *chieh-t'ou!*[34] He would certainly do us honour."

"Of course, why doesn't he enter? Is he too modest?"

"On the contrary, he is too proud—unwilling to risk it unless guaranteed first place. And I hear that Your Highness has already recommended Mr. Chang Chiu-kao?"

The Princess smiled and shrugged.

"Yes, someone asked me to do a favour but a woman can always change her mind." Then leaning toward Wang Wei, "So you want to be *chieh-t'ou*—or nothing?" Wang blushed and hung his head. She laughed. "I cannot allow you to be nothing."

Two years later, Wang Wei undertook the Imperial Examinations. The Chief Examiner was no less than the Chief of the Bureau of Examinations in the Ministry of Appointments. Candidates registered in the late fall at the Executive Division of the Imperial Government, although the examinations were not held until late February or March. Then the students must struggle with poetry and prose, answer questions on some of both the Confucian Classics and Taoist Canons. They were also required to write five essays on explicit, present-day problems of the Government posed for them.

The few months' interval before the zero hour might be considered a last chance for "swatting up." Not so. There were other means to the goal which could lead, after the spade-work was

55

done, often more directly to the coveted prize. Each young aspir-
ant must gain right introductions, cultivate the right people and
be able to claim some relationship, however distant, with a power-
ful official. Also, he must advertise himself. To get a reputation in
one of the creative arts, to go to any lengths to make his name
pass from mouth to mouth—pursuit of such activities might count
for more at this late stage than further study. A shocking essay or
an outstanding painting might be most effective in gaining notice.
A clever song, for instance, would soon be on the lips of all the
singing girls. Poets passed around their lyrics in the hopes of
recognition. Thronging with youth, Ch'ang-an blossomed in the
gay springtime and the constant series of parties afforded students
a possible opportunity to realize their ambitions—plus luck. Wang
Wei, already luckier than most of his fellows in contacts, passed
brilliantly. He was just twenty-one.

After passing the Imperial Examinations, Wang, like his grand-
father before him, was appointed to the Imperial Court as Asso-
ciate Secretary of Music[35] to train students for participation in
official ceremonies. His future could not have appeared much
brighter. He mingled with the ablest of the land.

It is surprising that music, the least of his three eminent talents,
brought Wang his first fame. One fable of his musical prowess
concerned the result of a famous farewell song, one so poignant
that the flute accompanying it—unable to bear the tension—split!

> *A morning rain has settled the light dust in the city of Wei,*
> *And slaked the thirst of green willows framing the guest house.*
> *Come, my comrades, drink with me one more cup of wine—*
> *West of the frontier you will meet no more old friends.*[36]

Although discredited by the sober minds, another such story
is too good to omit. Shown a painting of a performing orchestra,

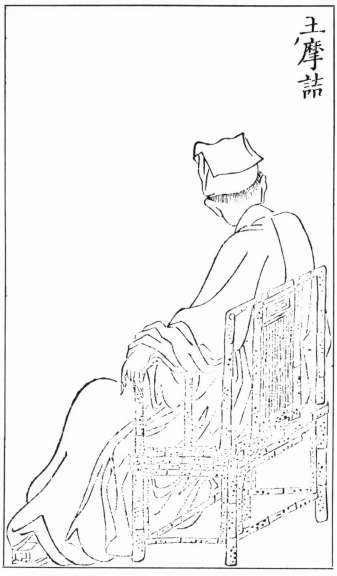

王摩詰

10. Portrait of Wang Wei, presumably a self-portrait.

57

Wang studied the mural several minutes and then remarked,

"They are playing the first time-beat of the third movement of the 'Rainbow Robe'."

He was challenged by a rival musician who sneered at his brash assertion. Wang did not argue the point. The challenger assembled an orchestra like the one in the mural and had them play the composition. No need to finish—Wang's point was proven long before.

Stories of his talent in poetry likewise went the rounds. A poem titled "Madame Hsi" enjoyed the happy ending of a fairy tale. One of Wang's close friends was the powerful Prince Ning, elder brother of the Emperor. Although possessed of "several tens of singing girls," each a past mistress of entertainment, Ning was ever responsive to fresh charms. Nearby lived a baker with a wife too desirable not to add to his collection. He appropriated her and installed her in his palace, giving a good sum of money to her husband.

After a year or so, one day the Prince was arguing with Wang Wei and several other literary guests the ephemeral value of affection. He offered to present a case in point. He called in the baker's former wife. The Prince asked her, certain of the answer, "Do you ever miss your husband?"

Her eyes immediately filled with tears and she was mute. Astonished, the Prince summoned the baker. Witnessing this moving scene, the guests were deeply stirred. The Prince asked each scholar to write a poem then and there (not an unusual request). While they were cogitating, Wang Wei suddenly recalled a parallel historical incident:[37] In the period of the Ch'un-ch'iu (B.C. 470–481), a ruler of Ch'u conquered the state of Hsi and abducted Prince Hsi's wife. Thereafter Madame Hsi rarely spoke. The King rather naively asked her why she was unhappy. She replied, "When a woman serves two husbands is it not disgraceful? What could you expect me to say?" There was silence.

When everyone was ready, Wang read his poem first:

> *In spite of today's Imperial Grace,*
> *She cannot forget the kindness of yesteryear's husband.*
> *Full of tears, she fixes her gaze on flowers,*
> *And will not speak to the King of Ch'u.*[38]

A hush fell on the assemblage. The point had been made with no reference to the baker and his wife. The verses by the other guests were forgotten. As for the Prince, he was so deeply moved that he relinquished the baker's wife to her home and husband.

OFFICIAL LIFE

IN THAT FLATTERING FIRST YEAR as an official at court, Wang Wei wrote a number of poems praising this glamourous life. Then a sudden blow taught him how precarious position can be—how dependent on the capricious whim of the Monarch. How true the saying from Confucius! "Rank and riches are like floating clouds."

Wang had committed some slight indiscretion, possibly reflecting on the royal image. Whatever it was, his punishment seemed out of proportion to his crime; except that anger rather than justice often motivated royal severity. Banished from the capital, Wang was sent far away to Chi Chow, the present city of Liao Ch'êng in Shantung. Homesick and depressed, he was relegated to a minor post[39] controlling Government grain storage and collecting taxes. As if this demotion were not humiliating enough, he was subjected to indignities that he could not believe the Emperor intended.

> *Here arrogant officers correct the culprit harshly,*
> *The wise Emperor may not have had this in mind.*
> *Houses march monotonously along the irrigated fields.*
> *A sea of thick cloud rolls over the village.*
> *Even if I should ever return,*

59

> *These lonely grief-crushed years will have stolen*
> *the hair from my temples.*[40]

For more than a decade Wang remained isolated unless, as is likely, his wife accompanied him. We do not know what year he married; we know only that when he was thirty-one, Madame Wang died childless. He did not remarry. During these years of exile, Wang must have found great solace in writing poetry and in the attempt to better his painting in order to fulfill a dream:[41]

> *I know I am admired as a poet,*
> *Yet in some former life, surely I was a great painter*
> *Since I still cannot suppress my deep inclination toward art.*
> *Too, I am considered an artist by common men—at least at times,*
> *Though not for my pictures—only my name—*
> *How little, oh, how little they understand what lies within my heart!*

In 734, Wang's good friend, Chang Chiu-ling, was appointed prime minister. Thanks to him, Wang was permitted to return to Ch'ang-an. In profound gratitude, he wrote of his high opinion of Chang's integrity. He considered him an enlightened statesman, a righteous and fair administrator whose policy of government was consistently for the welfare of the people. The men he appointed were judged by their talent, wisdom and worthiness. No bribery, political difference, or personal relationship could influence his decision. Unfortunately, Chang proved to be the last of the enlightened statesmen of the T'ang Dynasty.

Back at court, Wang Wei was no longer the gay trusting youth dazzled by glory. Although his devotion to the Emperor never flagged in spite of ill treatment, he did lose confidence in officialdom generally. Now he understood the devious ways of the court, the price of success, the compromise necessary to maintain position. In spite of his youthful ambition for political prominence to match that of his proud ancestors, the artist kept himself aloof

60

from that inner coterie intent on promotion through currying favour.

Soon after his return, Wang was appointed Commissioner of the Right[42] in the Government Department of the Secretariat.[43] Three years later he was promoted to the position of Censor of Inspection[44] in the Censorate[45] for Ho Hsi, the present province of Kansu. While there he wrote many popular patriotic poems lauding the war heroes fighting in the border warfare. These were widely read.

The office of censor was instituted in the Han Dynasty around the turn of the Christian era, beginning with one censor which was increased to six by the T'ang Dynasty. The occupation of censor is unique in history. It represented in theory the people's supervisory right over both the Government and the Emperor himself in spite of the latter's absolute power. The censor's duties consisted in making reports to the throne on all matters pertaining to Government administration both in the capital and throughout the Empire and especially on all conditions that needed rectification. The censor was also obliged to accept the perilous prerogative of going so far, when he deemed it necessary, as to criticize an Imperial Edict—or even the Emperor himself. The candidate chosen for this sacred trust was usually a man of unflinching honesty, of incorruptible integrity and one grounded in classical traditions. His most important virtue was almost superhuman courage:

"He who does not report any unseemly action on the part of an official is disloyal; he who does not report such actions may endanger his life as well as that of his family."

The censor well knew that he might also endanger his life if he did report. In theory, the person of the censor was sacrosanct; nevertheless in practice, a number suffered terrible punishment for their daring denunciations.

While censor, Wang Wei travelled quite often beyond the

61

province of Shensi into Kansu, the border territory where Chinese and barbarians met. We read in his poems of soldiers ordered to outpost duty there and of the life of guards and sentries.[46] This new experience broadened his mind and gave maturity to his poetry. His patriotic themes lauding the war heroes became very popular.

FRIENDS

IT WAS THE FASHION in this age for scholars and officials to own country homes that often included *shan chuang,* "mountain villages." Here, alone or with congenial guests, the weary could get away from it all for brief periods of vacation. Wang Wei's third and best loved such retreat, Wang Ch'uan, had formerly sheltered another T'ang poet, Sung Chih-wên (d. A.D. 710). It was situated about four miles south of Lan T'ien, a sleepy county town some thirty miles southeast of Ch'ang-an. Other prominent men occupied villas in the neighbourhood.

Wang Ch'uan was predestined to be as closely associated with Wang Wei as Stratford-on-Avon with Shakespeare. It became immortal through both his finest painting and most inspired poetry. Several of Wang's pictures reflect the magic beauty of the countryside.

As in ancient Greece, and characteristic particularly of the T'ang Dynasty, deep friendships among men of kindred spirit illumine the pages of Chinese history. The centre of frequent gatherings, Wang Ch'uan sparkled often with the keen interchange of renowned contributors to culture. These companionships made the difficult years more bearable, years inevitably shadowed by frequent separations and sudden uprisings.

P'ei Ti, a noted contemporary poet, often visited Wang Wei at Wang Ch'uan. To Wang's amusement, P'ei Ti often hummed his own poetry, so Wang entitled one of his own, "While Listening

to P'ei Ti Humming Poetry, I Compose a Poem to Him in Fun."

> *How bitter the wail of the monkeys*
> *Mourning from daylight till dark!*
> *Come now! Do not ape their cries in the Wu-hsia Gorge*
> *Lest you break the hearts of travellers on the autumn river!*[47]

For all their levity, both men were warmly appreciative of their friendship:

> *We have not seen each other—*
> *We have not seen each other for a long time.*
> *At the source of the stream, day after day,*
> *I recall how we used to clasp hands—*
> *Hand in hand, eye to eye—because we had the same heart . . .*
> *How I grieved when you left so unexpectedly!*
> *That is the way I feel towards you even today—*
> *This mutual love then—is it deep? Or not!*[48]

Mêng Hao-jan (689–740), another close comrade and poet, lived in the district of Hsiang Yang, Hupei. In his early manhood, he had adopted the life of a hermit, studying the classics and writing poetry in Lu Mên Shan, "Deer Gate Mountains." When in his forties, he emerged from his solitude with the idea of taking part in public life. He journeyed to the capital to sit for the Imperial Examinations. Although he did not take the examinations he succeeded in making fast friends with such noted men as Wang Wei himself, and the celebrated Prime Minister, Chang Chiuling. By then an official at Court, Wang enjoyed, like his colleagues, private quarters in the Imperial Palace.

One day, so the legend goes, when Mêng was drinking tea with Wang in the latter's private suite, the Emperor was suddenly announced. With a leap, Mêng dived under the bed. Too late! Ming Huang caught this undignified exit.

"Come out from under there," he ordered. Mêng scrambled to

his feet, face on fire. "I have heard of you. Since you do have talent, recite a poem."

Vainly trying to think, Mêng bowed many times and sputtered a most unfortunate title: "The Illustrious Ruler Discards the Untalented One."[49] Enraged at such apparent impudence, the Emperor stopped him.

"Untalented! How dare you contradict me? And to say I discarded you! You never sought office so how could I discard you?"

Refusing to listen to Mêng's apologies or Wang's explanations, the Emperor exiled Mêng forthwith to his home in the country. Not long after, the unhappy poet died.

In 740, Wang Wei travelled south to conduct examinations for local students. While passing through Hsiang Yang, he took the opportunity to make a pilgrimage to Mêng's grave. The following poem expresses his emotion:

> *I shall never see my old friend again . . .*
> *Day after day the Han River flows onward to the sea.*
> *Oh, elders of Hsiang Yang,*
> *Do the hills and waters of Ts'ai-chou keep silence now?*[50]

Two outstanding contemporary T'ang poets, still widely read today, were Li Po, born the same year as Wang Wei, and Tu Fu, born eleven years later.

Li was introduced to court in 742 while Wang was there. Depending little upon men's good will, this poet tried to avoid getting closely involved in the game of political treachery. A happy opportunist, he slid through life snatching at any temporary advantage, from that of high position as Emperor's favourite to the humble pleasure of a wanderer with friends both rich and poor. It sufficed him to enjoy life to the full—with plenty of wine, any available women and the exuberant singing of his own songs. Time left few scars on him, not even after the following porten-

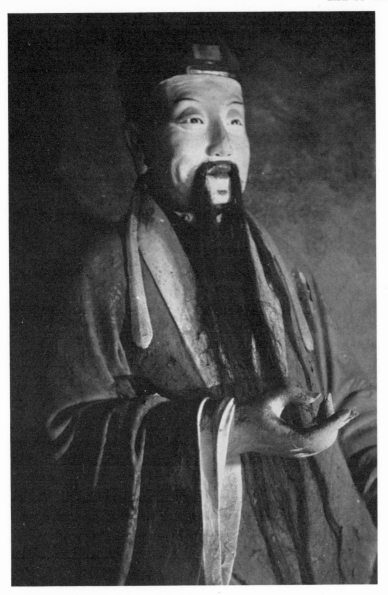

11. Image of Tu Fu in Ts'ang Ssŭ, Chengtu, Szechwan.

tous moment that dramatically combined his highest triumph and deepest disaster.

One irresistible June morning, the Emperor, accompanied by his entourage, trotted his favourite stallion, "Shining Light of Night,"[51] through Yang Kuei-fei's palace gardens. She followed him in her eunuch-drawn imperial carriage through thousands of pink and white peonies in full bloom. Suddenly overpowered by the full-blown beauty of both mistress and flower, the Emperor pulled up his steed. This scene must be immortalized in music. He quickly summoned sixteen of the best performers from the Pear Garden Conservatory. And since no old song was good enough for this occasion, Li Po must write a new one. But where was he?

The Emperor dispatched the orchestra director on a fast horse to find him.

Li was sprawling in a neighbouring wine shop too intoxicated to appreciate the honour. Buckets of cold water dashed in his face helped to sober him; news of the Emperor's command put him on his feet. Arrived at the royal gathering, the flattery with which he was received allayed his apprehension and restored his self-assurance that he was quite a fellow. Then his bleary eye lit upon an old enemy, the chief eunuch, Kao Li-shih, whose latest taunt—and that very morning—inferred that Li was a dog not worthy to pull off Kao's boots. Thanking the Emperor for the honour of writing the new song, Li threw himself down before his monarch and requested one small favour: Would the Son of Heaven order Kao to remove Li's boots while he was composing? The Emperor chuckled and nodded. What a triumph—Kao down on his knees obliged to comply and, at the same time, the Imperial Lady, no less, holding Li's ink pan! To make the moment last, Li promptly composed not one but three immortal poems. And final honour, Ming Huang accompanied on the flute while all the musicians sang Li's words.

But alas for poor Li! First pride, then the fall. He soon fell farther than he had risen because the humiliated chief eunuch in his turn took revenge. Surely the Emperor could see that one of Li's poems compared Yang Kuei-fei with that tiny Flying Swallow who, in spite of her allurements, was discovered to be a traitor. The unwitting poet hastily packed, left the capital and never returned.

In contrast to Li Po, Tu Fu (known as the poet's poet), although constantly struggling for official position, received only a minor appointment for a very brief period. In the year 735, he tried the Imperial Examinations. He was failed—but along with every aspirant—by the Prime Minister, Li Lin-fu who was jealous because he himself did not possess a degree. Wang Wei and Tu Fu enjoyed exchanging their poems and several of Tu's verses refer to his excursions to the Wang Ch'uan neighbourhood.

No list of Wang's friends is complete without mentioning again, Prince Ch'i, brother of Ming Huang, Chang Chiu-ling, the former prime minister, and Cheng Ch'ien, a scholar so accomplished in letters that in 750, Ming Huang established the Academy of Advanced Studies,[52] in recognition of this learned man whom he appointed its first dean.

THE CLOUDED YEARS (740–761)

THE CLOUDED YEARS from 740 on stifled Wang Wei with discouragement. He was forced to watch helplessly while political conditions rapidly deteriorated. The last of the upright statesmen, Chang Chiu-ling, had been thrown out of office because he had dared to advise strongly against changing the line of succession. A procession of incompetent sycophants had replaced him. The first, Li Lin-fu (who had failed Tu Fu), weazled his way into the Emperor's good graces through crass flattery, far less subtle than

67

that of the rebel, An Lu-shan. Subtlety was no longer needed at court: Ming Huang battened on praise be it false or true. By now his judgment was too much impaired to recognize any difference. Given a free hand, Li, that man of small calibre, hated especially the scholars because they might pose a threat to his power. Why he should have made an exception of Wang Wei is not clear unless the artist's patent indifference to politics made Li feel safe with him. Between 737 and 750, he promoted Wang a number of times and twice in 742.[53] If Li expected to win Wang's grateful respect, he failed dismally. Wang was not to be deceived by Li. A cynical wariness of Government service born of early exile from Court had crushed Wang's youthful illusions. Although accepting this steady advancement, he nevertheless kept out of the limelight so far as possible.

Financially, Wang was better off than many friends of an equivalent social standing: Li Po, lacking both wealth and position after dismissal from Court, scoffed at affluence and influence; Tu Fu lived in direst poverty, one of his sons actually dying of starvation; Mêng had not even tried the Imperial Examinations. A few of Wang's poems do suggest economic worry but the facts do not bear out his need for money. His family was never in want and was, more likely, well-to-do. He himself occupied a salaried official position almost continuously throughout his life.

The present Government of the People's Republic of China substantiates this belief: Since Wang Wei's poetry is said to reflect the wealthy upper class, little has been done to preserve his memory. On the other hand, the works and relics of Tu Fu, "the poet of the people," are honoured in an excellent museum erected in Chengtu, Szechwan, near the site of his "grass hut" beyond the West Gate of the city.

By 750, although Wang was still in office, he had made of it little more than a sinecure. What slight interest in the Government he had once shown seems for the most part to have become

submerged in his strong preference for writing poetry and paint-
ing. He escaped from political pressure, as often as he could, back
to his country villa at Wang Ch'uan and the life of the mind.
Some of his verses now exhibit a touch of mockery at the futile
lives of his colleagues:

> *After the morning levee, you will write the edict in five colours:*
> *Then, to the jingle of jade and gems, go proudly toward*
> *your home at the edge of Phoenix Pool.*[54]

Contrast with this a small vignette of one of Wang's country
days, written to his comrade, P'ei Ti:[55]

One day, I walked alone on the mountain. I rested at the Temple of
Appreciation and dined with the monks. After dinner I returned. . . .
At night, I ascended Mount Hua Tzŭ and saw, far down below, the
waves of the Wang River dancing up and down in the moonlight.
Distant lights on the cold mountain glittered now and then beyond
the forest. I could hear dogs barking in the deep lane. In the cold night,
they sounded like leopards. The beat of villagers pounding grain
alternated with the toll of a monastery bell.

Now the servants are quiet and I am sitting alone. . . .

Wang Wei's duties were broken abruptly in 751 by the death
of his mother with whom his ties of devotion had never slackened.
According to Chinese custom, as a filial son he took leave of ab-
sence, or, as the expression goes, "cast off his official robes" to re-
turn to the home where she had lived, for the traditional three
years of mourning.[56] He was so deeply grieved that he became
"like skin and bones" (a comparison current even now in the
West).

Five years later Ch'ang-an fell to the rebel An Lu-shan. Wang
Wei, caught in the maelstrom of war, was imprisoned either for
having vainly tried to follow the Emperor into exile or because
An Lu-shan was "anxious to see what kind of an animal a poet
was."

69

Tu Fu in "The Grass Hut of the Ts'ui Clan in the Eastern Mountains," comments poignantly:

At the Western farmstead of Wang, Supervising Censor: why is there Silence? pine trees! bamboos! the rough wood gate is closed and locked.[57]

In an attempt to set up a stable government, An proceeded to conscript all eligible members of the official class caught in Ch'ang-an.

Just what part was Wang forced to play in collaboration with the regime of An Lu-shan? It is not certain. Various stories tell of his resistance: He posed as a deaf mute; he took drugs which deprived him for a time of speech; he tried suicide, resulting in temporary invalidism. Without choice, he was appointed Assistant Secretary of the First Secretariat,[58] which kept him in Court. But he had no intention of debasing his literary talents in favour of the rebellion, nor did he.

Barely a year later, An Lu-shan was defeated. Ming Huang's son, the new Emperor, ordered all collaborators to be put on trial. Wang eluded severe punishment by two turns of fortune: a dangerous poem of protest against An's usurpation, written while imprisoned in the "Temple of Enlightenment"; and the intercession of his prominent brother, Wang Chin, Senior Secretary of the Board of Justice.

When An Lu-shan first triumphed, he celebrated his victory with wild barbaric revelry surpassing any staged by the ousted Emperor. For this he used the splendid pavilion, the "Palace of Condensed Greenness," overhanging the magnificent artificial "Frozen Pearl Lake."[59]

At the conqueror's command, all the Emperor's loyal musicians of the famous Pear Garden Conservatory were forced to give a performance. Completely unstrung with emotion, their fingers kept fumbling on their instruments and their voices kept faltering

until one of their number burst into tears. Infuriated, An ordered him immediately put to death.

Hearing of this outrage, Wang had whispered his poem lamenting the whole tragedy of the rebellion to his intimate friend, the poet P'ei Ti, when the latter managed to visit him in his prison cell.[60] Loyal Péi Ti lost no time in spreading it throughout the Underground:

> I am broken hearted: ten thousand families lost, turned into wild smoke!
> When again will the hundred officers wait upon the Emperor?
> Leaves from the locust trees litter the courts of the deserted palace . . .
> Yet listen! From the end of the Pool of Condensed Greenness
> come faint sounds of merry music.[61]

His brother Wang Chin went so far as to send a humble memorandum to the Emperor begging demotion for himself as expiation for the "guilt" of Wang Wei. Doubtless touched by so gallant an offer, the Emperor refused this sacrifice and released the prisoner.

The Emperor showed his renewed trust by rapidly promoting Wang Wei, first to the Office of Instructor of the Heir Apparent and then to Grand Secretary. The following year he became Deputy-Minister of the Executive Branch of the Administration,[62] a Government position next to that of Prime Minister.

Shortly after this, Wang Wei seized an opportunity to repay his brother's kindness. Wang Chin had been appointed Governor of Shu Chow, the present province of Szechwan on China's western border. This district, cut off from the more highly civilized areas of China, offered little in the way of culture to a governor although it held strategic importance for protection against the barbarians. Beseeching the Emperor to permit Wang Chin to return to the capital, Wang Wei pleaded:

I have five weaknesses in my character whereas my brother has five strong points: He is more compassionate, modest, righteous, generous

71

and virtuous. My brother is now in Shu Chow. He is diligently caring for the "hundred families," managing the work of the Government and guarding the cities. He is much superior to Wei in administration and literary achievement.

Although your subject Wei is honoured with a high position in the court, he is not worthy of it. For example, he can not compare himself with his brother. During An Lu-shan's rebellion, your subject fell into the hands of the rebels. In spite of this he preserved his life whereas his brother loyally guarded the city of T'ai Yüan for the Empire and governed the people with care and kindness.

Your subject, Wei, is now old, weak and has no heir. His days are limited. It will be a great comfort and pleasure to him if his brother can live near him during his remaining years. Will Your Majesty let his brother serve the Empire with a minor post in the capital while your subject, Wei, with Your Majesty's permission, will retire to private life and yield his high position to a more worthy man?[63]

Not long before his own death, Wang wrote a memorial to the Emperor about his mother. Its contents are roughly as follows:

I can never repay the kindness of my mother. I should like to do all that I can in this respect to ease my conscience. When I think of those in the Buddhist faith who give up their lives to obtain merit and to help the spirits in the other world, I think of my mother. A lady of the Ts'ui family she was a devoted Buddhist for more than thirty years. She had led a simple life and loved living in the quiet mountains. I therefore established for her a country residence at Lan T'ien with a shrine on a mountain where there were bamboo groves and fruit orchards. Here my mother enjoyed sitting in meditation and reading the scriptures.

According to the Buddhist faith, the suffering of the souls in the other world can be relieved through merit and virtue. Ever since my mother's death, I have intended to make my own country home a monastery for Buddhist monks although I have never expressed before my feelings about this.

Now that (Your Majesty's) restoration has taken place, everyone is happy. I am moreover honoured as a high official "although ordinary rotten wood." I do not know how to repay your kindness. I hope that relying on the grace of the Buddha you will be blest with long life to

rule this Empire. The desire of my heart therefore becomes even stronger.

Now for my country, as well as for my mother, I beg to present with Your Majesty's approval, this village with a monastery where seven monks will care for it and carry on the Buddhist faith.

Thus I attempt to repay my gratitude to Your Majesty and also to my mother.

Your humble servant,
WANG WEI

Never suspecting that he had won immortality on earth, the poet-painter died in July, 761. He was buried at Wang Ch'uan in "Deer Forest Hermitage," one of the twenty places of scenic beauty, not far from the grave of his mother in the "Temple of Clear Spring."[64]

Years later, Emperor Tai Tsung remarked to Wang Chin, then Prime Minister:

"I knew your brother when he was a young man. I met him from time to time at the homes of noble families. He was a great patron of the arts and a great writer. Make for me a collection of all his works."

Although Wang Wei left ten volumes of essays, poems and other writings, his brother was able to collect only about seventy per cent of the manuscripts to present to the Emperor. The rest of the hand-written copies had disappeared. The invention of printing had not yet blessed mankind with the wide publication of books.

An ancestral temple for the Wang family was erected at the foot of Deer Park Mountain. When travelling through that area of Shensi province in 1957, I solicited the aid of historians and archaeologists to trace all possible records referring to Wang Wei. No one in the district seemed aware even of the Wang ancestral temple although histories do note its restoration in 1835, little more than a hundred years ago.

73

When I arrived at Lan T'ien from Si-an, I was shown supplements to the "District Histories" with recent articles about Wang Wei and his villa at Wang Ch'uan, illustrated with woodcuts. In the outer courtyard of a former Buddhist temple (now the town post office) I saw set in the wall ten stone tablets engraved with poems by Wang Wei and also poems by P'ei Ti which were written to Wang Wei. Other stone plaques were carved with sections of the "Wang Ch'uan Scroll," Wang Wei's famous work. Time would scarcely permit me to make a pilgrimage to Wang Ch'uan as I had hoped to do. Nor did the total lack of roads encourage me to try. Walking along a narrow footpath offered the only means of transportation. And if I did make the effort? I was told that nothing material now remains to identify the painter's beloved villa. Better for me to cherish in mind and imagination that home of beauty and spirit. Better to keep my own picture of it, slowly built up from traces of pictures of pictures and from bits and pieces of research.

CHINESE PAINTING PRIOR TO WANG WEI

THEORIES

DURING THE NORTHERN and Southern Dynasties (420–581) when Taoism had become decadent and before the assimilation of Buddhism, Chinese thinking was largely controlled by animism, mythology and Confucianism. Much from Confucius offered a fertile field for stone engravings and drawings: Indeed, the *raison d'etre* for painting was primarily moral instruction along Confucian principles. Surely painting, like poetry, should teach moral attitudes conducive to reinforcing contemporary social standards? Thus, titles for pictures: "The Story of the Filial Grandson Yüan Ku" and "Admonitions of the Imperial Instructress to the Ladies of the Palace." In addition, the artists illustrated hunting expeditions or commemorated the heroism of a patron's brave ancestor on the field of battle.

Primarily concerned with human affairs, art usually placed man as the centre of interest, just as he was the centre of the then known universe. The sketched figure symbolized mankind quite in line with Confucian humanism. This humanistic idea was further

implemented in early T'ang times, by the rise of a strong, young, united China, pre-eminent among all nations in the East.

In art, there seemed to be little attempt at likeness. The picture told the story and the imagination filled in likeness where likeness was desired. In the tiles of the late Chou and Han Dynasties, designs of horses, deer and flying geese are frequently drawn with the figure of man but each design is equally spaced from its neighbour and not connected to it. In a few imprints, conventionalized shapes of trees stand between figures, not added as landscape but primarily for decoration.

As early as the second century B.C., critics started to question the use of art solely as a handmaiden of ethical education. In the first writings on painting, we sense the authors' intuition that possibly a much wider field could be explored. Queries on technique also arose; perhaps after all an artist should strive for resemblance? Rebellion broke out over the inclusion of minutiae in pictures. In the philosophic "Huai Nan Tzŭ" composed in the second century B.C., we find the statement: "An artist with too much regard for details spoils the appearance of his work. By slavishly trying to paint every minute detail an artist loses sight of the essentials."

About 400 A.D., Sun Ch'ang-chih compiled the first book on art, "A Record to Explain Painting."[65] This manual probably disappeared some time during the T'ang revolutions. Now only isolated phrases from it are still extant. A contemporary of Sun with the same name as Wang Wei[66] but born some three hundred years earlier and not related to that Wang family, wrote several short essays on the theory of painting: "Paintings," he states, "are not produced by the mere exercise of manual skill, but on completion, must correspond to the phenomena of the universe as explained in the 'Book of Changes.'"[67] In the same century, Hsieh Ho drafted general principles of aesthetics to guide artists in evaluating their own pictures and also to appraise painting in general. Like

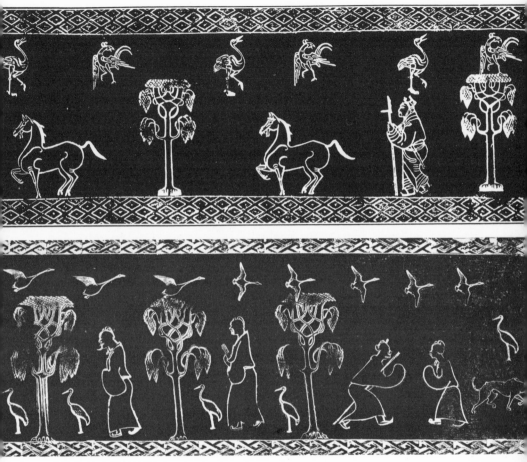

12–13. Tomb tiles, former Han Dynasty, 206 B.C.–9 A.D., courtesy of the Royal Ontario Museum, University of Toronto.

Confucius, he was an editor and a transmitter, not a creator. His earliest recorded outlines, "The Six Principles of Hsieh Ho,"[68] set forth the ideas behind technical experience enunciated by previous artists drawn from long practice.

77

First: A picture should demonstrate movement, life, rhythmic vitality, purity and originality of inspiration.

Second: A painting requires anatomical structure or "bones" established by the right use of the brush.

Third: A painting should be in conformity with nature; that is, possess correctness of outline.

Fourth: The colouring should be appropriate to the subject matter.

Fifth: Attention should be given to composition; a correct division of space; a satisfactory grouping of objects.

Sixth: Masterpieces must be copied in order that classic models may be transmitted to future generations and that painters be guided by former masters.

To the Chinese artist, the First Principle was supreme: He must carefully observe the method of achieving such perfection.

Even if these guideposts were not literally adhered to through the succeeding ages, they did serve, nevertheless, as a solid point of reference. As already mentioned they did set down particularly valuable guides for criticism and appraisal, never standardized before. Of course, even by Wang Wei's time, there were art historians and professional art critics in the field. Kuo Jo-hsü writes of "Wet-ink" Li, who went among the mansions of the wealthy to make estimates of their paintings. As they sometimes do today, however, Chinese art critics were inclined to rely too readily on the reputation of the artist rather than on the merit of a painting.

RELIGIOUS INFLUENCE ON ART

NOT UNTIL THE SIXTH and seventh centuries, did Buddhism join Taoism and Confucianism as a dynamic force in Chinese thinking. The Buddhists enriched the Chinese intellect with new philosophical concepts. They implanted fresh life into the old body of Chinese art. They contributed to it a mine of religious motifs. The effect on painting was revolutionary. While man—tem-

porarily—retained his position as a central figure in composition, his form was radically altered. Entering China from Gandhara, north-west India, Buddhism imposed its characteristics upon the Chinese religious figure—the slender waist, the sinuous line, the heavy ornamentation, the prominent Graeco-Indian hips, the latter a legacy from the passage of Alexander the Great. Religious themes grew increasingly prominent. Under Buddhist inspiration, art assumed an immensity never known before. Vast murals spread far-reaching plains toward limitless horizons and threatened the onlooker with colossal deities of terrifying power.

Buddhism made its strongest impact upon the sensibilities of the educated Chinese, adding a content absent in Confucianism and challenging the somnolence of Taoism. Under this threat, Taoism awoke and strove to excel even the wealth of the Buddhist hierarchy, ritual and symbolism. In various ways, one religion reacted favourably upon the other. Both were steeped in mysticism and both peopled the seen and the unseen world with myriads of fantastic spirits.

Preoccupation with religion was further strengthened by the constant danger resident in politics throughout much of the Six Dynasties. Men of intelligence were becoming disheartened by the stupidity of continual warfare. Perpetual plunder by irresponsible factions made all life insecure. More and more men fled when they could to mountain hermitages, where they sought solace in meditation, in poetry and in painting. As Wang Wei wrote:

Dwelling here quietly, why should I ever leave home?[69]

Man and his human activities gradually lost their grip as the centre of interest.

At an earlier age, by placing their temples in the loveliest settings of mountain, stream and valley, the Taoists had developed a nature cult through which appreciation of nature, even worship

79

of nature led naturally in time to expression in landscape painting. Landscape painting in turn became dominated by Taoist practice just as earlier the principles of Confucius had dominated figure painting.

We cannot correctly attribute this deep attraction to nature wholly to Taoism. There is much evidence of an inherent love of it in the Chinese character. As early as 400 A.D., we read in "Records of Famous Paintings of all Dynasties," of the artist, Tsung Ping (375–443), who painted on the walls of his home all that he had enjoyed of the natural world in his travels. When he grew too old to roam in the mountains, he found great satisfaction wandering in his dreams among the scenes he had painted.[70]

EARLY LANDSCAPE PAINTING

THIS NEW PAINTING—landscape—was destined to remain to the present day the most characteristic type of Chinese art and the best loved. According to Kuo Hsi in the eleventh century:

> Having no access to the landscapes, the lover of forest and stream, the friend of mist and haze, enjoys them only in his dreams. How delightful then to have a landscape painted by a skilled hand! Without leaving the room, at once he finds himself among streams and ravines; the cries of the birds and monkeys are faintly audible to his senses; light on the hills and reflection on the water, glittering, dazzle the eyes. Does not such a scene satisfy his mind and captivate his heart? That is why the world values the true significance of the painting of mountains.[71]

It is not surprising that the painting of scenery, *shan-shui*—literally, mountains-and-water—should achieve the status of an end in itself; no longer mere background nor primarily decorative nor subordinated to moral or religious subject matter. The landscape

artist now approaches his task in a spirit of reverence with a ritual, a *li,* not incomparable with the elaborate *li* of ceremonial conduct. The Chinese sense of the appropriate in conduct guided the appropriate preparation for painting. We can no more ignore the significance of this than the value of the Japanese tea ceremony.

A punctilious procedure with minor changes was cultivated for centuries. Tsung Ping, that painter who covered his walls with the scenes of his travels, and a contemporary of the famed Ku k'ai-chih, writes that Ku courted the muse, "by living in leisure, by nourishing the spirit, by cleansing the wine glass, by playing the lute, and by contemplating in silence before taking up the brush to paint."[72] All of seven centuries later, the son of Kuo Hsi describes his famous father carrying on the same ceremony.

On a day when he, Kuo Hsi, was to paint, he would seat himself by a bright window, put his desk in order, burn incense to his right and left, and place good brushes and excellent ink before him; then he would wash his hands and rinse his ink-well, as if to receive an important guest, thereby calming his spirit and composing his thoughts. Not until then did he begin to paint.[73]

He relates his father's habit of reciting high-minded passages of the ancients in order to inspire his painting. One such passage was from Wang Wei:

> *I walk to the place where the waters end;*
> *I sit and watch the rising clouds.*[74]

Late in the Six Dynasties, the long tradition of Chinese art underwent a mutation—so unlikely an event could be accounted for only by an extreme change in this static environment. A migration of peoples in and around the capital arose heading southward to get away from conditions intolerable even to the limitless patience of the Chinese character. The pressure of a soaring population with its concomitant scarcity of food; the oppression of a

corrupt Government with its blind, avaricious imposition of higher taxes; the cupidity and exactions of the wealthy steadily growing wealthier; the insecurity of chronic civil warfare—against these, leaderless and with no plan but escape, the people left. Among these pioneers were many artists who, in search of a new life, came into closer contact with nature than they had ever been privileged to experience before. A new sense of freedom carried them onward over mountain passes of exceptional beauty, mountains more formidable and overpowering than the familiar northern hills. The artists were challenged to find new modes of expression for new depths of feeling: The conventionality of Han faded into past history. A fresh, descriptive element in landscape transformed the former decorative style. Under this new revolutionary life the philosophy of painting for a time outstripped the performance. Man's spirit was conceived in relation to the cosmic Spirit which, in turn, was regarded as the cogent power of growth in the universe—the Way of Heaven called the *Tao*,[75] that primal life-pulse beating through the heart of the earth. Therefore we find much discussion among the art critics and theoreticians of such problems as essence, divine spirit, breath, life-movement—familiar terms to the Taoist but difficult to define. Essence, the Chinese believed, dwelt in every person as the integrating force of his total physical and psychic self—that which stamps him as an individual.

But in these discussions, again the question of likeness to nature arose. What place did realism possess in painting? Was realism then, as Sir Herbert Read thinks, ". . . an expression of confidence in, and sympathy for, the organic processes of life"?[76] Or were the merits of spiritual essence superior to these as pronounced by Yao Tsui (*c.* 550): "Truth is not so important as the mental and spiritual discipline an artist obtains through his effort to give full expression to the true nature of the object he paints." The "true nature" meant capturing his inner experience of the object,

valued far more than technical skill in reproducing its likeness.

Many anecdotes highlight the deep concern of artists in the conflict between essence and likeness. In the eighth century an official, Chao Tsung, commissioned Han Kan to paint his portrait, and later on to make a sketch of him. Chao Tsung could not determine which effort excelled. When the artist consulted Chao's wife, she replied, "Both are like him, but this second one is the better. For the first has merely caught my husband's features, while the second has caught his disposition and the way he looks when he is speaking with a smile."[77] On viewing Li Ssŭ-hsün's painting in a newly completed door screen, Ming Huang said, "Your skill is more than mortal; at night I can hear the splash of the water in your picture."

As for realism, of course there are countless legends of painters whose luscious cherries cheated the birds; whose fish swam away when inadvertently dropped into a stream; and whose birds and dragons they dared not finish with eyes lest they fly away.

However when analyzing pure landscape, consideration of realism did not enter. The experience of nature, a full consciousness of its overwhelming mystery, was an integral part of man's sense of the total mystery of life. It was this mystery, not realism, which the artist sought to expose in the practice of landscape painting. Why? Because this intimate encounter with nature deepened his realization of union with it. He might appear insignificant and alone before overpowering mountains but he did not feel alone. The sense of oneness with the natural world about him added a personal quality to his efforts. This elusive belonging he tried to place on silk, the poignant instant insight, the moment of awakening for his own spirit. "Landscapes were most instrumental for his purpose, for landscapes have a material existence, and yet reach also into a spiritual domain," wrote Tsung Ping. Man's advance in the philosophy of *Tao* forced the progress of art beyond former goals.

83

Such illumination may sound abstruse for us in the West to understand because intimacy with nature as the Oriental artist knows it, is almost completely alien to us. It disappeared with the seventeenth-century revolutions in science, philosophy and industry.[78]

In attempting to answer, at least in part, the reasons why the Chinese artist became absorbed in, or obsessed by, landscape painting, let us ask ourselves also, how did he succeed in producing classic masterpieces appreciated all over the world?

We of the West might say it is because of an arrangement with a true sense of balance in composition. De Riencourt[79] gives the Chinese reason: it is because of the way in which the Chinese artist orients the elements in his landscape—mountains and valleys, rocks, trees and waterfalls—in alignment with the principles involved in *fêng-shui*. According to *fêng-shui*, "wind and water," the topographical components of a locality control the fortune or misfortune of that site. The position of hills or prominent rocks, direction of water-courses, mountains to the north or south, every one of these exercises a special moulding influence. To achieve the most beneficial effects, the selection of a site, say for a temple or house or grave, must be governed by the rules of geomancy. Similarly in a picture when the parts are properly composed in harmony with these principles, the resulting composition will be most satisfying provided that, at the same time, the artist paints with directness and sheer, uncluttered simplicity. In this way he captures the significant form in his subject.

Another reason for his success in producing classical masterpieces: The Chinese artist has his roots firmly planted in the thought-forms of his people. The sap from such roots is captured, transformed and preserved in a great painting. Nowhere in the world is the philosophy of a people so clearly expressed in its landscape painting as in China. Geographical surroundings have conditioned his work. He derives his creative energy from the yellow

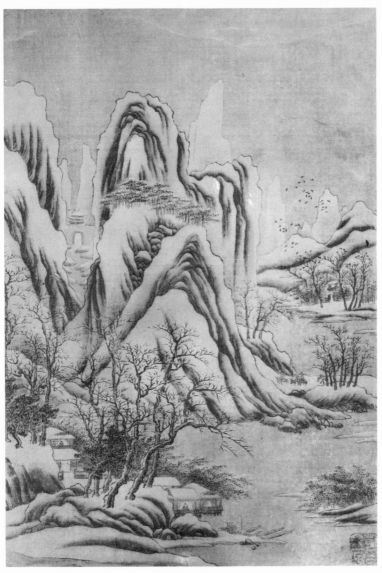

14. Landscape, "After a Fall of Snow," attributed to Wang Wei, location unknown. Illustration number 1 in *Reproductions from Works of Famous Chinese Artists,* Yu Cheng Book Company, Shanghai.

85

earth. The master painter is able to impregnate the ephemeral with the eternal. The enlightened beholder responds to the resulting cosmic harmony.

ARTISTS PRIOR TO WANG WEI

FROM THE EARLIER ERAS of China's culture, a paucity of important works of art and only a few authentic monuments still bear witness to the soaring spirit of man. The miracle is that any have survived. In 618 A.D., his Empire crumbling, Emperor Sui Yang Ti tried to transport his precious art collection—one of the first—across the Yellow River only to lose the whole of it. All that is left of the extensive gallery of a later Emperor, Hui Tsung (which included many of Wang Wei's works) are a few pages in a detailed catalogue. What connoisseur could possibly have managed to save these flimsy remnants—and at a time when looting barbarian hordes (1125) were driving the royal house of the Northern Sung all the way south of the Yangtse River.

Similar disasters are repeated over and over in Chinese history. Numerous priceless pieces belonging to Ch'ien Lung (1736–1796) were scattered. In the Sino-Japanese war (1937–1945), the Chinese Government shipped caravans of imperial treasures from Peiping for safe-keeping overland to a Buddhist temple in the foothills of Mount Omei, Szechwan. But when the hundreds of boxes later reached the refugee Government in Taiwan, it was discovered that somewhere en route, clever thieves had rifled dozens of them substituting stones for the contents.

We must depend then on copies of paintings, on literary records, on legends, on uncertain stories and on anecdotes to chalk out the pattern of Chinese painting during that time-distant era.

Names associated with enduring art before Wang Wei are scarce. That of Ku K'ai-chih ranks far above all others and refer-

ences to several of his pictures occur repeatedly in treatises on Chinese painting. Working in the latter part of the fourth century, he had few contemporaries and apparently no rivals; the lack of competition only sharpened his ambition to achieve the ultimate. Using suggestions of scenery for background, he painted portraits, and figures often of religious deities in Buddhist frescoes.

A legend about the young Ku K'ai-chih shows a talent for business unusual in an artist. When a new temple was being erected, Ku was commissioned to decorate the walls. To pay for the construction, a subscription was taken up. To the general astonishment, this unknown painter himself subscribed a fabulous sum far exceeding that of many wealthy Buddhists. How could one so comparatively obscure hope to raise so much? And where? Curiosity mounted, especially when for days Ku locked himself behind high walls in the temple compound and was never seen. Then when his payments for his pledge were almost due, Ku posted an admission fee for entrance to the temple. Puzzled throngs of sightseers stood in line to view—what? A magnificent fresco, Ku's masterpiece. And soon the curiosity of the sightseers had paid his commitment for him in full.

A copy of Ku's most outstanding creation is that quaint hand-scroll in the British Museum: "Admonitions of the Imperial Instructress to the Ladies of the Palace." The subject is taken from writings on etiquette by Chang Hua (232–300). Considered a T'ang representation of the original, this copy is near enough to Ku's own time to present a fairly accurate idea of his composition and technique. His primitive landscapes still retain much of the early archaic spirit and form. Mountain peaks are "like combs or hair pins," human figures loom larger than mountains. Composition was still limited in those days by strict conventions that only later could be by-passed by superior artists. These pictures are devoid of perspective and atmosphere like the early Italian paintings. They correspond to mediaeval work in the West before painters

began to relate human figures to their natural environment or to grapple with the special challenge of landscape.

Both the Freer Gallery, Washington, D.C. and the British Museum display copies of parts of Ku's illustration, "The Nymph of the Lo River." Washington also owns copies of his sketches illustrating verses by a third-century poet Ts'ao Chih whose father, Ts'ao Ts'ao, founded one of the states of the Three Kingdoms.[80]

Because of the close association between the technique of painting and the art of calligraphy, the name of Wang Hsi-chih, "the man who reformed the whole art," should be mentioned here. He lived nearly four hundred years before Wang Wei and is still famed as China's foremost penman. "His work is light as floating clouds, vigorous as a startled dragon," writes an appraiser. Rubbings from Wang Hsi-chih's writings engraved on large stone tablets have provided copy-book material for every generation of schoolboy since.

In the sixth century, Chang Sêng-yu (active 450–550) captivated the art world with his superb snow scenes. He also portrayed Buddhist and Taoist figures. Chang believed that colour itself could stand without outline and innovated a style of painting known as *mo-ko,* "boneless," or with hidden bones.

Three other eminent artists preceded Wang Wei: Yen Li-pên, Li Ssŭ-hsün and the latter's son, Li Chao-tao.

Yen Li-pên (active 650–670) led as a figure painter. One of his best known works, "Portraits of the Emperors," graces the Boston Museum of Fine Arts and exhibits clearly the domination and dignity of the T'ang Dragon Throne. His manner is similar to that of Ku K'ai-chih. The figures are done in line drawings of even thickness. The areas within the outlines are washed with harmonizing or contrasting tints. Colour and shading, it is claimed, were introduced through Buddhist influence from India.[81]

88 The most renowned of the three artists was the aristocrat, Li

15. "The Nymph of the Lo River," detail from a Sung painting after Ku K'ai-chih, courtesy of the Freer Gallery of Art, Smithsonian Institution, Washington, D.C.

Ssŭ-hsün, (651?–716) frequently called General Li. His great-grandfather, Li Yüan, founded the T'ang Dynasty. With such lineage, Li easily rose to the position of artist at Court, spending his luxurious life chiefly within royal palaces. The sumptuous hues he chose clearly reflect his environment. A late imitation, "Palaces and Gardens on Fan Hu," suggests his design and strong palette.

Li is sometimes regarded as a pioneer in the evolution of T'ang landscape painting. His work, however, is reckoned as dry, academic, and belonging to *kung pi*—that tradition which emphasizes detail and loud colours. His elaborate landscapes were stud-

89

ded with elegant royal palaces and arched bridges in blue-greens, reds and whites.

Li Chao-tao (670–730) doubtless influenced by his father Li Ssŭ-hsün, likewise painted bright landscapes in gold, green and blue. The younger Li's most creative period overlapped the life of Wang Wei by almost thirty years.

All of the above-mentioned painters were professionals before Wang Wei was old enough to produce anything of significance: Indeed, before we have any record of his future major interest. Still, he knew of their masterpieces and the court honours which rewarded them. This glamour would no doubt make a strong impression upon the young man and would help to create the atmosphere conducive to his artistic ambition.

Among Wang Wei's contemporaries, Wu Tao-tzŭ (active 720–760) received highest official recognition. Wu was already a Court painter when Wang went to the capital in 719. According to legend, this stormy petrol was born in poverty and orphaned at an early age. A devout Buddhist, he entered a monastery from whence he derived much of his inspiration and future subject matter. When only twenty, he was called to the Court, given official rank and became a prodigious worker. Attributed to him are more than three hundred large religious frescoes for temple walls in both capitals. He displayed a new, eerie, subtle style as indicated by a twelfth century art critic:

> This picture which was painted by Wu Tao-tzu is very different from those now to be seen in temples and pagodas. It is no 'knife forest' (where the wicked are impaled on swords), no cauldron of boiling water, no ox-headed or green-headed lictors: and yet its gloomy horrors are such as to make beholders sweat and their hair stand on end, themselves shivering all the time though it may not be cold. It has caused men to seek virtue and give up evil practices; after which who can say that painting is only a small art?

90 Besides being influenced by Buddhism and Taoism, religious

painting had derived much élan from the Hindu and Persian traditions. Now Wu adapted these new variations to a distinctly Chinese idiom, which continued through the centuries. He abolished the classical, hieratic style of the sixth century. His figures were unmistakably Chinese figures with the Chinese cast of countenance and body, his *Kuan Yin,* "Goddess of Mercy," a Chinese *Kuan Yin.* Under his hand the human form sprang to life with unprecedented animation. The flowing lines of drapery moved with the wind. His deities radiated an air of divine authority, the sublimity of eternal love and the compelling power of compassion. Spirituality emanated from them. When Wu prepared to place the aureole about the head of a divinity, silent crowds gathered in awe to watch his flawless lightning swish.

This artist, about 725, introduced a new mode of painting vitalized with calligraphic outline—lines of varying instead of even thickness—a method much less dependent upon colour for effect. In later years, Wu specialized in line drawings; the double contour and single outline like the work of Yen Li-pên. The spaces within the borders were frequently filled with colour, although often ink alone was employed.

The work of several contemporary lesser painters is analogous to that of Wang Wei. Both in title and in spirit, a landscape by Yang Sheng is a case in point: "Snow Over the Mountain Along the River" (Palace Museum, Taiwan). This recalls Wang Wei's "Snow Clearing Away on Hills by the River" although, in comparison, the atmosphere of Yang's is turgid.

Another contemporary, Lu Hung, was appointed a Court painter while Wang Wei was still a student. Lu's "Ten Views from a Thatched Cottage" (also Palace Museum, Taiwan) expresses in black and white a poignant loneliness through the contrast of small men with boundless space. Wang Wei's most famous painting, "Wang Ch'uan Scroll," is not unlike Lu's. Indeed, Wang's painting strikes one as being too similar to Lu's style to be ac-

91

cidental. Wang may have followed the older man's work as a stepping-stone toward his later artistic development. Some of Wang's names for his favourite places are also reminiscent of Lu's titles: "Green Shelter," "The Immortal's Path," "Truth-Seeking Cavern," and so on.

Han Kan (active 742–756), the eminent painter of horses in the T'ang Dynasty, happened to be a protégé of Wang Wei. In early youth, Han had served as chore boy in a wine shop; his chief duty to look after the customers' horses. Wang Wei and his brother, Wang Chin, often stopped by to fill their flasks before riding into the mountains. While waiting around, Han liked to sketch their steeds in the dust of the road. Recognizing a genius, Wang Wei provided Han for ten years with no mean sum for training— 20,000 cash annually. Better yet, he directed the lad's artistic studies himself.

No doubt Wang Wei was well acquainted with all the contemporary palace artists. There was Chang Hsüan (active 714– 742) a society painter of beautiful ladies and gallant youths; there was Ch'en Hung, portrait painter to the Emperor. And of course, there were the non-conformists and "beatniks" of the time. Among them was Chang Tsao, who, when banished from official position, devoted himself entirely to art. He used "two brushes simultaneously, making with the one a living branch and with the other a decaying trunk." As another technique he would, on occasion, wield a stump brush or smear the silk with his hand. An envious admirer, Pi Hung, ambitious to equal him asked the name of his master. Chang replied, "In externals, I have taken as my model the creative processes of nature; within, I have the springs of my own heart." The effect on Pi was disastrous: He had access to no such "masters" as these; he laid down his brushes forever.

The methods of Wang Hsia sound like those of some of our own far-out artists. When drunk, he would dip his head in a pail of ink and drag his hair over the painting-silk. Marvellous moun-

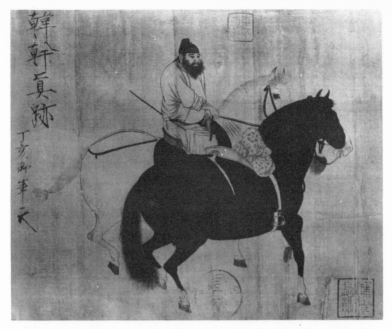

16. "Central Asian Groom with Two Imperial Horses," attributed to Han Kan, an album-leaf from the Manchu Household Collection.

tains, lakes and trees emerged as if by magic. Or, having soaked his paper with masses of ink, he would sometimes kick and smudge it, until sunset or rainstorm loomed up—and without a trace of the first spilling.[82]

Another group, the grandiose painters, should at least be mentioned. There were also those escapists into Buddhism, Taoism and various philosophies. Indeed the eighth century in T'ang China fostered creative stirrings of the heart, a seeking after farther horizons for the meaning of life.

To most, art was a deeply serious business. Small opportunity existed for a Hogarth or a Picasso, men who caught the irony of the age, or for the "artist who was aware of the suicidal despair of his time and laughed at it hysterically."

93

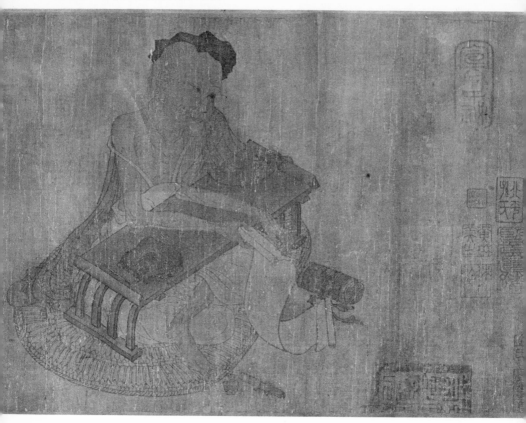

17. "The Old Scholar Fu Shêng Engaged in Restoring the Text of the *Shu Ching*," after Wang Wei, probably late T'ang or early Sung period, courtesy of the Abe Collection, Osaka Museum, Japan.

WANG WEI
THE PAINTER

EARLY EFFORTS

MANY CHINESE AUTHORITIES acknowledge Wang Wei to be not only the greatest landscape painter of the T'ang Dynasty but of all dynasties. In the art world, his name became legendary.

According to the *Shu Hua P'u* written in the eleventh century, Wang Wei began painting at the age of nineteen soon after his arrival in Ch'ang-an. We have little information to guide our study of this early period of his work. We do know that he did some portraits and figure painting. For example, his long-suffering friend, the poet Mêng Hao-jen, modeled for him on horseback while humming verses from the "Book of Odes"! Of his cousin Ts'ui, Wang wrote much later:

> *I painted your portrait when your years were young;*
> *Now I have painted you when you are old*
> *Yet in this picture I discovered a new man!*
> *I understood you better in the old days....*[83]

Wang's figure paintings consisted chiefly of Buddhist deities and included at least four full length portraits of Vimalakirti, his

patron saint from whom he took his familiar name, Mo-chieh. The Osaka Museum, Japan, owns one (possibly original), "The Old Scholar Fu Shêng Engaged in Restoring the Text of the *Shu Ching*."

Wang Wei did a portrait of himself ". . . beneath an image of Buddha. He wore a cap, like a spirit of peace, a yellow gown. He clasped his hands in a pose of worship."[84]

Wang's first essays at landscape seem to have imitated, like all young aspirants, the style of the late Li Ssŭ-hsün then the fashion. Naturally therefore some of Wang's early pictures resemble Li's; detailed, highly decorative and strong in colouring. Such flamboyance soon tired and bored Wang's meditative temperament.

Wang's older contemporary, Wu Tao-tzŭ, next influenced him. The T'ang critic, Chu Ching-hsüan, (writing around 840) judged Wang's scenes of pine trees, mountains and rocks, although similar to Wu's, to be superior in atmosphere. Petrucci[85] goes so far as to say that Wang established the principles of atmospheric perspective: How tints are graded; how forms grow indistinct in proportion to their distance; how the increasing thickness of layers of air casts a bluish tinge over remote objects like mountains and sky.

Increasingly, Wang Wei departed from figure painting and from peopling his scenes with men and dwellings. He preferred to stress the expansive natural setting about him. As he subordinated the individual to the might of nature, his interest in scenery for its own sake gradually emerged. This new emphasis foretells his main absorption, one well in advance of his time—pure landscape.

Eventually Wang struck his own stride—after that he followed no master. He agreed with the old Chinese proverb: "An artist

18. *Next page:* "River Landscape with a Boat in Winter," attributed to Wang Wei, formerly in the Manchu Household Collection.

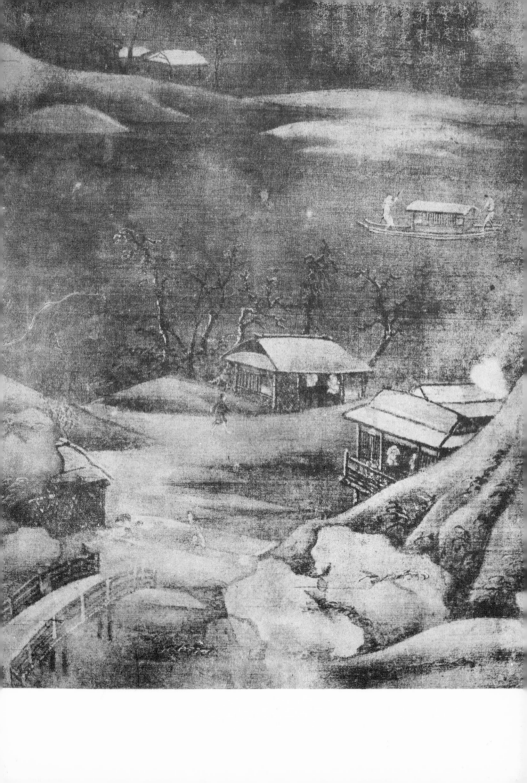

must take nature as his master and yet be true to himself." As Wang advanced to his own mature style, his innate music and poetry inevitably created the lyric quality found in his later subject matter. As he retired further and further from the strife of political life, more and more the quiet solitude touched by the changing seasons appealed to him. A tranquil technique of graceful flowing lines enabled him to manifest his sensitivity to nature.

Wang now brought to his art the knowledge of the savant— the first traces of that innovation in painting later to be known as the *wên-jên-hua,* scholar tradition. In the sixteenth century, the title of "Scholar's Painter" was conferred upon him. The cultured, educated man who leisurely painted for pleasure idealized this type of artist and the output of such artists was classified as the School of Literati Painting.

Wang mixed his colours with that mystical flow of spirit so prevalent in Taoism and Buddhism. His tendency towards replacing the fashionable intense colours with plain black and white may have sprung from lines in the "Tao Tê Ching," the Bible of Taoism:

> *The five colours dazzle the eye. . . .*
> *Give the people simplicity to look at. . . .*[86]

Or was interest in monochrome derived from Wang's fascination with snow? Time and again he would return to painting winter scenes. Something in the fresh magical purity, the hush of new-fallen snow rendered in monochrome satisfied him better than when done in colour. Monochromes became popular with later artists and several copies of Wang's landscapes still extant exhibit neutral values.

19. *Next page:* Rubbing from stone engraving after Wang Wei, from the "Forest of Tablets," Provincial Museum, Si-an, Shensi, courtesy of the Director of the Museum.

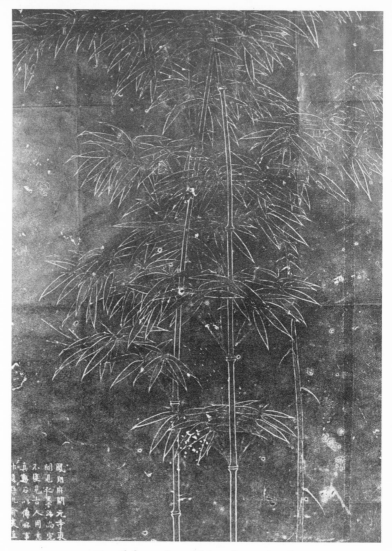

20. Detail from the rubbing shown in plate 19.

100 If not the first to paint bamboo, Wang is rated by Li K'an[87] (1245–1320) as one of the three outstanding masters in this field.

21–22. Examples of Wang Wei's style in painting: *left,* "Double Outline" used for trees; *right,* willow trees. From *A Mustard Seed Garden Manual.*

Engravings on stone tablets of two paintings formerly in a K'ai-yüan temple now stand in the "Forest of Tablets," Shensi Provincial Museum, Si-an.

> *T'ang people love bamboo.*
> *Who was the first (painter)?*
> *Wang Wei painted it best.*
> *He built a tea house on the West Farm*
> *And painted Bamboo there.*[88]

23–24. Examples of Wang Wei's style in painting mountains. From
A Mustard Seed Garden Manual.

TECHNIQUE

PAINTERS EARLY BUILT up a special vocabulary descriptive of each
variety of brush stroke—such as *yü tien ts'un,* "raindrop," for
small pointed ovals, and *fu p'i ts'un,* "cuts from an axe," for
elongated triangular strokes. Wang painted leaves with very fine
lines, the *kou lê,* "outline." For rocks, he used the *fei pei,* "flying
white," and to emphasize their hard sharpness, the *ku fa,* "basic

102

主山自為環抱法
前圖猶籍客峰以成氣象茲則特舉主山
自為環抱一法以其昂首舒臂象象包羅
無眼外景畫之更為深靜所謂置壁本喜
無假襯貼者是與前作較高則大君臨明
堂群侯朝拱此則恭黙用道深宮獨處之
時為主右丞嘗用此畫主山。

structure." He shaped hills with irregular broken movements of
the brush.

Wang himself invented other novel techniques. That most
frequently associated with his name is *p'o mo,* often translated as
"broken ink" style. It consists mainly in controlling the amount
and density of the ink on the brush and in broadening his strokes
in order to separate the ink-line into "fibres." The effect of tex-
ture results because the strands possess different tone values and
may even create the illusion of colour. Sometimes *p'o mo* is de-
scribed as wet-ink painting, a free sketching of ink masses without
precise outlines. Wang initiated the *hsüan jan,* "soak-ink" method
—shading with graded washes, or from one tint to another. He

103

25. Characteristic Wang Wei drawings of people. From *A Mustard Seed Garden Manual*.

was the first to moisten his ground thoroughly. The completed work looked like a wash drawing. "Fluid ink is supreme," to quote him. Also for textual quality, "brush-dots" spotted the outline drawings of rocks and tree trunks. Especially for branches, he often depended upon the *shuang kou*, "double outline," formerly employed by Wu Tao-tzŭ.

Perhaps most praised was Wang's ingenious rendering of *ts'un fa*, "wrinkles." This technique clearly delineated the flutings of mountain ranges, pointed up their basic shapes and exposed the patterns of trees and the profiles of landscapes.

26. A characteristic Wang Wei waterfall, from *A Mustard Seed Garden Manual*.

27. An example of Li Ssǔ-hsün's style.

When the authenticity of a picture was in doubt, the "wrinkles" often supplied the clue. For instance, Wang's sixteenth century champion, the critic Tung Ch'i-ch'ang, judging "Snow on the River," deduced that it could not be an original Wang: "It has no wrinkles but only contours."[89]

106 "The Mustard Seed Garden Manual of Painting,"[90] was a ref-

釣勒梧桐見王維輞川圖

28. Wang Wei drawing of the wu-t'ung (wood-oil) tree.

erence book for art students, perhaps the first of the "How To Do It" books. It comprised examples of how the "great" painted everything—people and houses, birds and animals, hills and rivers. Included are sketches illustrating Wang Wei's painstaking techniques, and, in supposedly his own words, the way to paint mountains:

107

To paint mountains, one must first know their spiritual forms and so be able to distinguish between the pure and impure elements. One may then determine the various attitudes of the peaks and select the position of the host and guests. When there are too many peaks, the effect will be confused; too few, the effect will be dull. . . .[91]

Tung Ch'i-ch'ang quotes Wang Wei as saying that clouds, peaks and cliffs should be formed as by the power of Heaven; then, if the brush-work be free and bold, the picture will be penetrated by the creative power of nature.

As for waterfalls:

When one is painting a waterfall, it should be so painted that there are interruptions but no breaks. In this manner of 'interruptions but no breaks,' the brush stops but the spirit (ch'i) continues; the appearance of the flow of water has a break but the idea (i) of it is uninterrupted. It is like the divine dragon, whose body is partly hidden among the clouds but whose head and tail are naturally connected.[92]

This rule of Wang Wei is well illustrated on page 105 in a drawing by Tung Yuan (d. 962). Critics regard Tung's painting as analogous to that of Wang Wei.

Painters over the years laid down other rules:

Understand the character of what you paint. . . .

If you paint a fish, you must feel like a fish; you must envy him his life in the water. Otherwise your picture will look more like a fish on a dish than a live fish swimming. . . .

The pine tree; a venerable scholar, stern and dignified. . . .

The willow tree; a delicate lady, all gentleness and grace. . . .

Voids often say more than solids.

If you paint a mountain, let the mountain appear like a prince with the hills spread around him as vassals.

Wang Wei's attitude toward his landscape was subjective. He sought to delve beneath external likeness for significant form. Frequently as a result his paintings exhibited uncanny nuances of

29. Strokes showing a variety of leaf forms, from Fei Ch'eng-wu's *Brush Drawings in the Chinese Manner.*

feeling, similar to the undertones of emotion aroused by today's Andrew Wyeth. Tu Fu described the effect on himself:[93]

> *Ten days to paint a mountain*
> *Ten days to paint a rock?*
> *The true artist works slowly,*
> *And Wang Wei is a great master.*

> *Here are the King-lun mountains,*
> *Here too the village of Pa Ling:*
> *I seem to hear the very noises*
> *Of the little crooked village streets.*

> *Here is the Lung-ting Lake,*
> *And here the silver thread of a rivulet.*
> *The wind sighs in the tree tops,*
> *And the clouds pile up in masses:*
> *Will that lonely fisherman*
> *Rowing there so desperately*
> *Find shelter before they break?*

Wang could also produce photographic realism. A legend demonstrating this has survived the centuries. He painted a large rock for Prince Ch'i. One day in a storm, a gusty wind ripped the picture from its frame and blew it away. Shortly after, envoys from the King of Korea appeared bearing a real rock deposited, so they said, on Mount Shen-sun by a great gale. Because it bore Wang Wei's seal, it obviously belonged to the Emperor of China; naturally the King of Korea dared not keep it. A close comparison of that rock with others in Wang Wei's paintings convinced the Chinese Emperor that those and the missing one were identical. Thereupon the rock was enshrined in the palace and to discourage its wandering spirit, the blood of a cock was poured over it.[94]

Deeply impressed, the Emperor concluded that Wang must be aided by magic. Forthwith the Son of Heaven gathered together a large collection of the artist's paintings.

茅屋蕨樓屋茨
温蔗葦
崒葯蓮
頹壑童
手一巻坐老
知是黄
庭内扨
維摩
經詰

30. Detail from Lu Hung's "Ten Views from a Thatched Cottage."

ORIGINAL PAINTINGS

NO PICTURES OF COURSE, exist today that can be assigned with
certainty to the brush of Wang Wei. Nevertheless two sources of
information about them are available; those in various museums,
catalogued as "after Wang Wei," and "in the style of Wang
Wei"; and the commentaries of critics and connoisseurs who had
either first-hand familiarity with his paintings or were cognizant
of them.

111

32-40. The Wang Ch'uan scroll, after Wang Wei, attributed to Chao Mêng-fu, 1309, reproduced in full, courtesy of the British Museum.

Wang Wei's outstanding innovation was the horizontal scroll. This revolutionary device extends immeasurably the artist's range of landscape painting[95]—and, quite as important, the viewer's delight. As the long scroll, sometimes more than twenty feet in length, is unfolded a panoramic sequence of pleasant scene after

31. *Opposite page:* Detail from a woodblock print by Wang Ch'uan T'u, taken from the *Lan T'ien County History* showing the following places named in the "Twenty Poems of Wang Ch'uan Valley," printed in the *Poems by Wang Wei,* numbers 35-43: "At Rapids of Luan Family," "Waves of Willow," Pavilion by Lake," "South Hill," and "Stream of Powdered Gold."

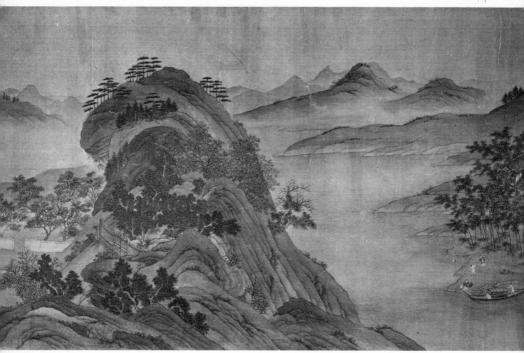

33. Caption on page 113.

scene greets the eye creating a unique impression of taking a journey through the countryside. Each section, a perfect composition in itself, reveals neat little farm houses dotting the winding pathway through cultivated fields, hamlets and villages clustered in bamboo groves, mountain streams or secluded valleys, or perhaps a river junk either towed or rowed slowly along a canal.

Of all Wang Wei's paintings, the most famous is the "Wang Ch'uan Scroll." This seventeen foot scroll[96]—the earliest horizontal one known[97]—is described in a catalogue of old paintings listed during the early part of the nineteenth century by T'ang Liang of Suchow. Within this long scroll, Wang Wei presents all the

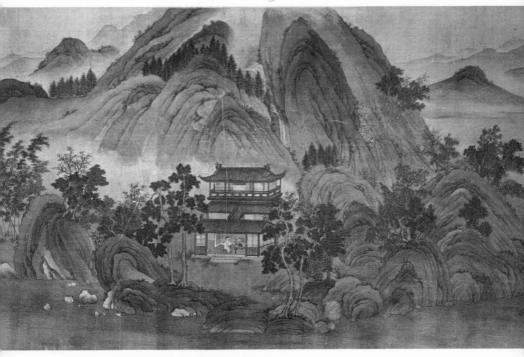

34. Caption on page 113.

especially beautiful places in and about his beloved home, places
that held for him precious associations, places that he had already
immortalized in a series of twenty poems, some under such poetic
titles as; "Rivers of Dogwood," "The Stream of Powdered
Gold," "The Lacquer Tree Garden," "My Study Among Beauti-
ful Apricot Trees."[98] Accurate draftsmanship throughout can be
taken for granted, but this work is imbued with much more than
careful technique and satisfying composition. Here is expressed
Wang's overwhelming love of nature and his absorbing joy in
friendship. The winding Wang River appears and disappears
playing hide-and-seek along the course of the foreground. About
the hillsides are scattered pavilions and snuggled in among the

115

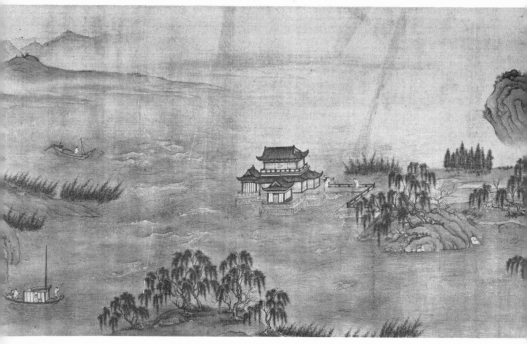

35. Caption on page 113.

bamboo groves are little tea houses and guest cottages. These quiet
retreats are peopled with his beloved companions, the artists, the
poets, the friendly Buddhist priests.

Laufer compares this master-work with a Beethoven symphony:

". . . and the Pastoral Symphony is the translation into music of the
Wang ch'uan t'u."[99]

Versions of this work are to be found in many collections.
Among the best known is that by Chao Mêng-fu[100] dated 1309, in
the British Museum. Chao uses predominately blues and greens
on warm brown silk. However, critics are divided as to the
authenticity of style or detail in Chao's work. Another copy by
an unidentified Chinese artist belongs to the Museum of Cologne.

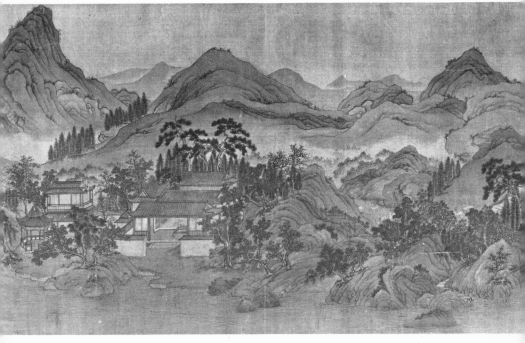

36. Caption on page 113.

One Sung rendering by Kuo Chung-shu (*ca.* 918–978) is in the joint collection of Professors Kobayashi and Shigeki Kaizuka, Kyoto. The catalogue of Ch'ien Lung's collection lists another copy by Li Kung-lin (1049–1106).

A striking similarity can be noted among the later versions of the Wang Ch'uan Scroll, particularly in general composition. Various techniques give some indication of the period of their production. Early examples like that owned by Professors Kobayashi and Kaizuka possess the "wrinkles" associated with Wang and his "hemp fibre strokes" suggesting gradations of light, shade and atmosphere that illustrate aerial perspective. These clues are lacking in still later versions.

117

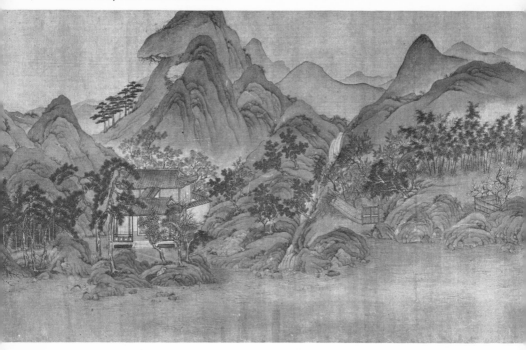

37. Caption on page 113.

Wang Wei kept the original "Wang Ch'uan Scroll" for himself.
In a temple which he provided for the purpose at Wang Ch'uan
he carefully guarded it as one of his most valued treasures. About
fifty years after Wang's death Li Chi-fu, twice prime minister of
China and an ardent collector, obtained ownership of this painting
and prized it so highly that only on rare occasions did he show it
even to intimate friends. Some authorities state that the distin-
guished artist, Kuo Chung-shu, possessed the scroll for a time
during which he painted the copy now in Japan. It would appear
that almost all later versions must have been derived from Kuo's
since this information is the last authentic trace of the original.

118 Nevertheless, so widely had the scroll's wonder spread that for

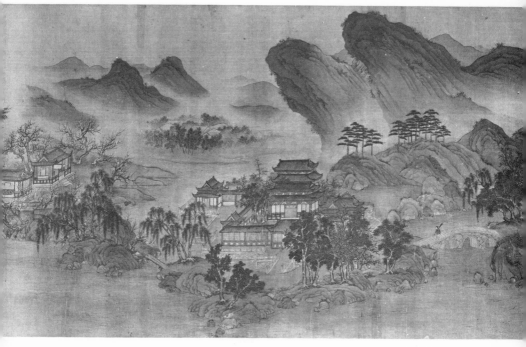

38. Caption on page 113.

many decades artists vied with one another attempting to capture its mystery in their reproductions. According to Bachhofer,[101] clues to the likenesses of early copies could be found in "some features such as a house with converging depth lines." Artists in Wang's time used this "modern" method, which was superseded after the tenth century.

The almost occult faith in Wang's work as being possessed of magical properties grew into a fairy tale[102] with the centuries. In the eleventh century, Kao Fu-chung, an artist and the poet, Ch'in Shao-yu, so much admired the work of each other that they became intimate friends. Ch'in was taken ill and after several days showed no sign of improvement. Deeply worried, Kao gave much

119

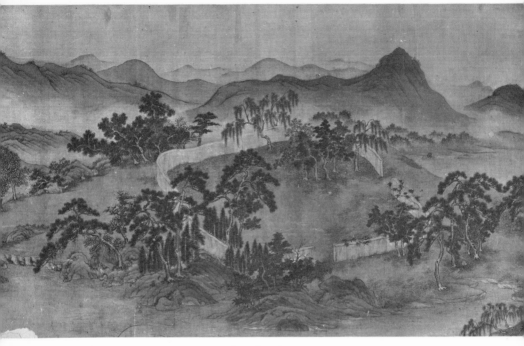

39. Caption on page 113.

thought as to how he might help him. Suddenly the answer came.

Whereupon he rushed to his friend and scarcely stopping to greet him cried, "Put down your heart. After you have seen this picture you will be well. It is the Wang Ch'uan Scroll."

Ch'in ordered his two boys to unroll it. Immediately lost in admiration, he suddenly experienced a strange certainty that he was actually entering the district of Wang Ch'uan companioned by Wang Wei. They wandered about all the scenic beauty spots —The Hill of Graceful Bamboo, Waves of Willow, Magnolia Hermitage, White Stone Bank, Lake Yi—quite forgetting that he was in Ju Nan. He saw happy people playing chess and writing poetry. He had lost all awareness of present time and place and

120

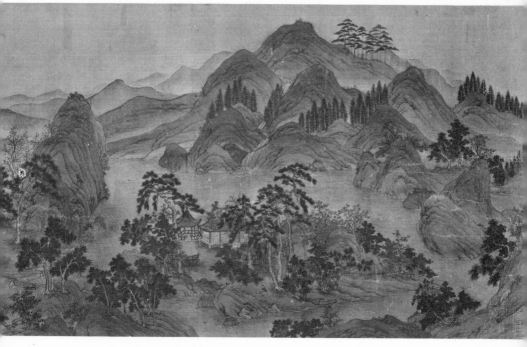

40. Caption on page 113.

of himself as a patient; in a few days he was well again. The writer comments:[103] "This story may seem strange and mysterious —that a person may be so affected by a work of art, receiving from it nourishment for the spirit, that he forgets all about his illness. This does happen."

In 1617, as a memorial to Wang Wei, an engraving of the "Wang Ch'uan Scroll" on five slabs of stone was erected on the site of his home. A Ming artist, Kuo Shih-yüan, modeled the design from the copy by Kuo Chung-shu. A rubbing from that stone engraving is now in the Chicago Natural History Museum— Laufer received this gift from an official in Si-an. He believes that although the original "Wang Ch'uan Scroll" transcended the

121

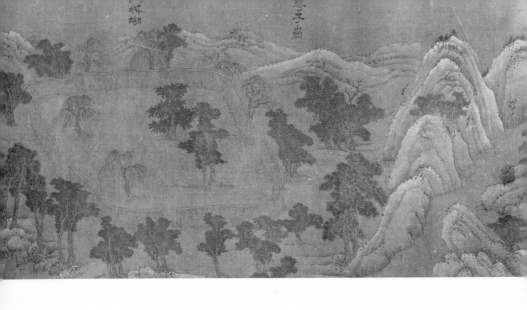

41–44. The Wang Ch'uan scroll, sections II and VII, after Wang Wei. Those shown at the top of this and the next page are from the late Ming period or are early Ch'ing copies of the Kuo Chung-shu version, *ca.* 918–978, in Japan, shown at the bottom of this and the next page. The upper illustrations are reproduced through the courtesy of the Seattle Art Museum and those below, through the courtesy of Professors Kobayashi and Kaizuka, Kyoto, Japan.

122

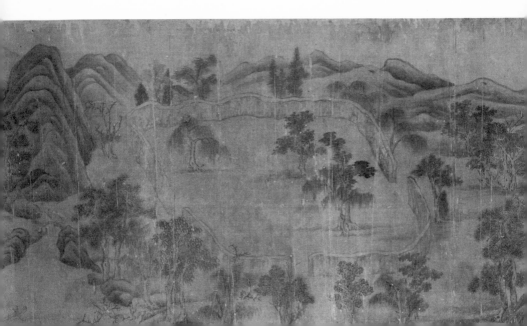

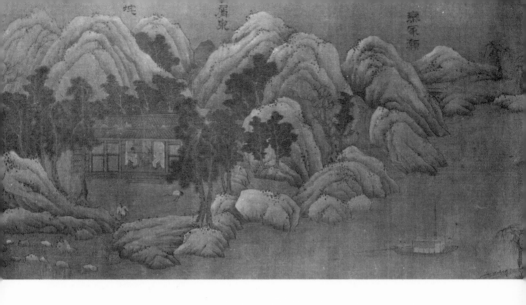

present copies, this rubbing, so similar to Wang's own brush work, reveals much of the poet-painter's characteristic sensitivity. Laufer goes further; he regards Wang's work as "one of the most remarkable and precious documents of Chinese psychology we possess."[104]

Another of Wang's paintings most frequently reproduced is

123

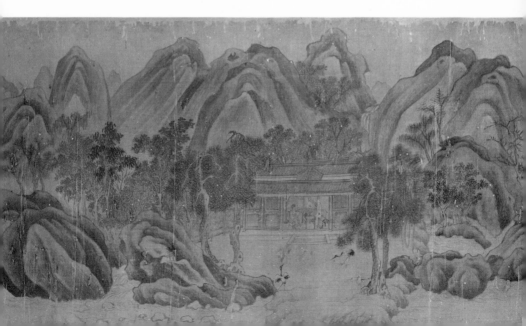

45–46. The Wang Ch'uan scroll, sections I and VI, after Wang Wei, signed Kuo Chung-shu (early Sung period), courtesy Shigeki Kaizuka, Kyoto, Japan. Section I is shown on page 124; Section VI, above.

also associated with Wang Ch'uan: "Clearing After Snowfall in the Mountains Along the River." The work of a genius was imperative for this latter scroll "to contrive a harmonious composition wherever the spectator pauses." Binyon describes it as: "A philosophic idea intended to represent the passage of the soul through the pleasant delights of earth to a contemplation of the infinite."[105] A copy formerly in the collection of Lo Chên-yü in Tientsin, then owned by Alice Boney, New York, is now in the Honolulu Academy of Arts, Honolulu. Dr. Ho Wai-kam of the Cleveland Museum of Art believes that this copy is probably

125

47–48. *Above:* The Wang Ch'uan scroll, detail, after Wang Wei, signed Kuo Chung-shu, courtesy of the Harvard-Yenching Library, Harvard University, Cambridge, Massachusetts.

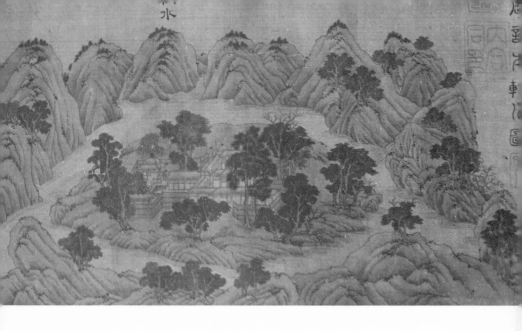

49–50. *Below:* The Wang Ch'uan scroll, detail, after Wang Wei, from rubbing of stone engraving, courtesy of the Chicago Natural History Museum.

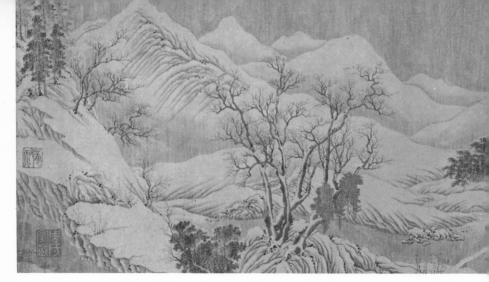

51-58. *Above, below and on next three pages;* "Clearing After Snowfall on the Mountain Along the River," in eight sections, after Wang Wei, probably a seventeenth or eighteenth century copy, courtesy of the Honolulu Academy of Arts, Honolulu.

very close to the style of Wang Wei. Another Ming copy[106] is in the Harvard-Yenching Library, Cambridge. The Ogawa Collection in Kyoto University Library, Kyoto, Japan, guards still another. The Art Institute of Chicago has on loan a scroll entitled, "Landscape View of Wang Ch'uan and Chuang Villa."[107] This bears a strong likeness to the above-mentioned paintings. Yale University Gallery also has a copy after Wang Wei though not

128

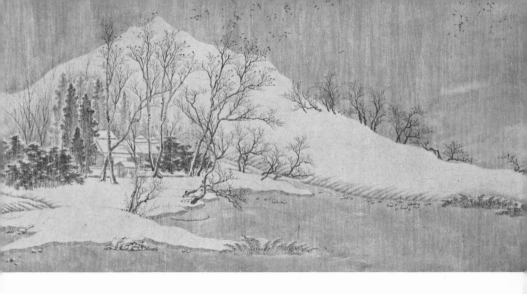

so near to the original as the others. This one is conjectured to be either by Emperor Hui Tsung (an accomplished artist himself) or else to be a copy of a copy by Hui Tsung. To be sure, the twelfth century catalogue of this Emperor's extensive collection ascribes one hundred and twenty-six paintings to Wang Wei. But doubtless many of these were not originals.

Let us describe from written records some of Wang's other works. "The Return of the Sage to His Country Home" sang a melody on the glory of spring among early plum blossoms, bamboo shoots and swollen mountain freshets. This poem in paint

129

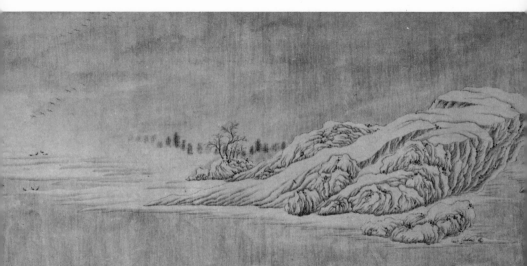

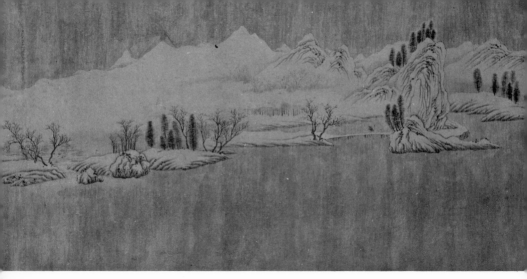

55–58. Caption on page 128.

suggests more of grandeur than the gentle mystical mood usually attributed to Wang. Not even one copy of this has survived the ages.

"Bananas in the Snow"[108] aroused much controversy. What! A banana tree in full purple bloom struggling under fresh heavy snow? Some critics deplore such an anachronism as a break with natural law. Others defend it: does not the true artist always search for inner essence, unobligated to follow exact external verities?

130

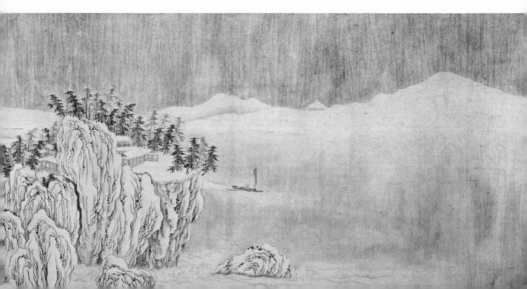

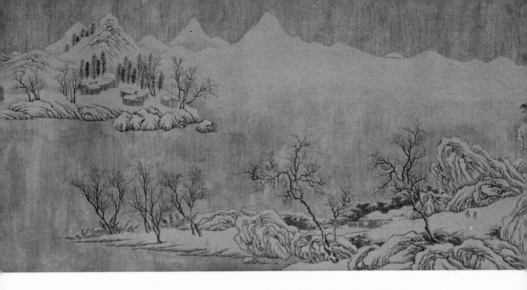

In still another picture, Wang annoyed the literalists by placing —all in the same setting—blossoms symbolic of the different seasons; plum blossom, apricot, hibiscus, water-lily.

"Waterfall" was long thought to be an original. Although the "broken ink" technique of Wang Wei's time is used, an analysis of strokes discloses that it is shared with "splashed ink" technique, one almost unknown until the Sung Dynasty.[109] This Sung copy is in the collection of Otauka Kogeisha, Tokyo.

By the eleventh century, originals by Wang Wei were extremely rare. Apparently the only surviving fresco was one in the eastern wing of the K'ai-yüan temple at Feng-hsiang.

59–62. "Clearing After Snowfall on the Mountain Along the River," two sections, after Wang Wei, signed by Yen Wen-kuei (967–1044),

courtesy of the Fogg Art Museum, Harvard University, Cambridge, Massachusetts.

133

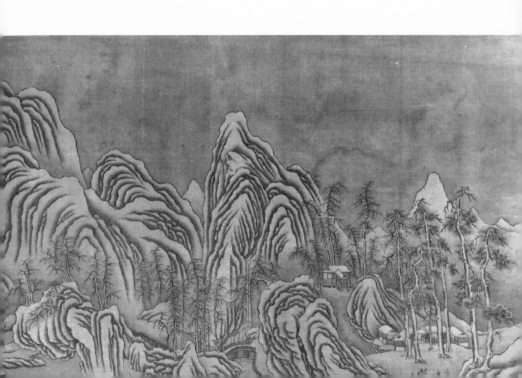

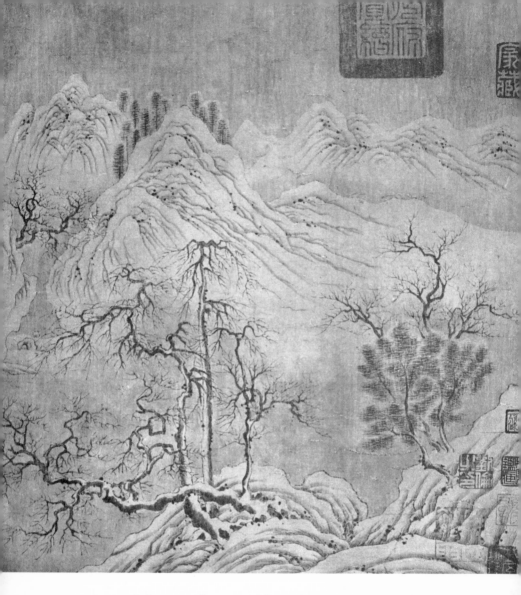

63. "Clearing After Snowfall on the Mountain Along the River,"
Section I, after Wang Wei, possibly a seventeenth or eighteenth cen-
tury copy. Considered close to the style of Wang Wei, courtesy of the
Honolulu Academy of Arts, Honolulu, Hawaii, formerly in the collec-
tion of Mr. Lo Chen-yü, Tientsin, and later in that of Miss Alice
Boney, Tokyo.

134

64. "Clearing After Snowfall on the Mountain Along the River," Section I, after Wang Wei, courtesy of the Ogawa Collection, Kyoto University Library, Kyoto, Japan. Compare this with the version shown in Plate 63 on the opposite page.

135

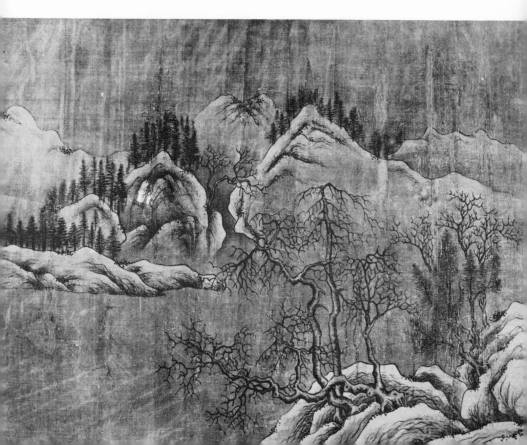

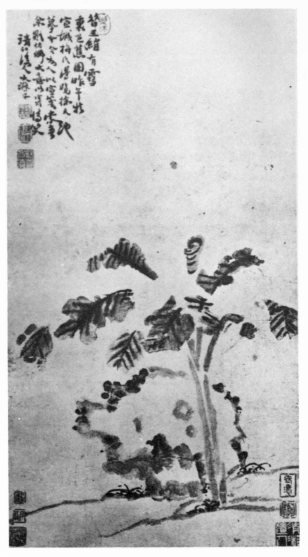

65. "Bananas in the Snow," after Wang Wei, by Tau Tsi, seventeenth century, from *Scraps from a Collector's Notebook,* by Hirth.

66. "Waterfall," formerly attributed to Wang Wei, probably a Sung copy, courtesy of the Chishakuin Temple, Kyoto, Japan.

As already mentioned, one of the portraits formerly attributed to Wang is in the Abe Collection, Osaka Museum, Japan, titled: "The Old Scholar Fu Shêng Engaged in Restoring the Text of the *Shu Ching*." The Japanese critic, Seiichi Taki, ascribes it to the late T'ang or early Sung Period.[110] According to Cohn, on the other hand, this painting ". . . seems to be identical with the one noted down in Emperor Hui Tsung's catalogue. . . ." At least the work can be credited only to a revolutionary master of the first rank, like Wang Wei.[111]

By the eighteenth century, Emperor Ch'ien-lung (1736–1796) 137

possessed only one original, a small album sheet, "Snow by the Stream."[112] He did have a copy of Wang Wei's villa by Li Kung-lin, "Lin Wang Mo-chieh Wang Ch'uan;" also two paintings by Kuo Chung-shu after Wang 'Wei. Two pictures, "Snow on the Ford,"[113] and "A Snowy Scene,"[114] mentioned in numerous Chinese catalogues were both formerly in the Imperial Manchu collection.

A fair number of the paintings "after Wang Wei" are faithful reproductions, representing to a creditable degree the spirit of this master but making no pretense at being originals. Done by outstanding artists, the copies themselves are worthy to rank as masterpieces.

Arthur Pope explains it thus:

So great is the sense of traditionalism and so firmly have the designs of the great masters of T'ang and Sung seized hold of the minds of later painters that the composition is almost always essentially good. . . . By reason of his training the Chinese painter is above all complete master of his brush. . . .[115]

Among the talented disciples who tried most seriously to imitate Wang Wei (far too numerous to mention them all) were: a top landscapist during the Five Dynasties (907–960), Li Sheng from Szechwan; numerous students from that remote province; Fan K'uan of the early Northern Sung Dynasty; Chao Ta-nien, a cousin of Emperor Hui Tsung, and Chao Po-chu of the Sung; Wen Cheng-ming (1470–1559?) and Ch'iu Ying (1522–1560).

Two examples of Wang's authority may be observed; one in Wang Ch'i-han's exquisite landscape on a panel of a screen titled "Reading"[116] and the other, Liu Sung-nien's scroll, "Snow Scene,"[117] both in the Metropolitan Museum, New York.

The centuries continued to put no stop to the Chinese torch-bearers of Wang's undying flame. As recently as the nineteenth century, the foremost Chinese landscape painter, Tai Shun-shih

(d. 1860), studied Wang's technique; he himself displayed Wang's love of snow scenes, as exemplified in "Mount Lan in Snow."[118]

That Wang Wei became a particular favourite among the copyists is obvious. For generations, their replicas aroused more eager competition among collectors than those of any other artist. In Japan, particularly during Ming times, Wang Wei was the most popular of all Chinese artists.

It must be remembered that copying masterpieces was an essential part of the training of the Chinese artist. Innocently enough, he liked to make presents of these copies for friends or to add them to his own collection. Since the medium of the original was on fragile paper or thin silk, both quite perishable, copies were also made to insure the survival of excellent likenesses for posterity. The custom of turning them out for mercenary purposes occurred much later, but when it did, myriads of counterfeit Wang Wei's, flaunting forged signatures, innundated the market. Mi Fei of the Sung, well acquainted with the original *Wang Ch'uan Hsüeh Chi T'u,* also saw several copies.[119] His son quotes his father as saying:

> I have seen more (copies) of Wang Wei's "paintings" than of anyone else. They are all like carvings not worthy of study. . . . (The painters) try to paint snow. Whenever (collectors) see a picture with snow and find the strokes are fine and elegant they say it is by Wang Wei. . . . Now all the noble and wealthy families own paintings by Wang Wei —there could not possibly be so many![120]

Various types of copying included tracing, accurate reproductions by drawing free-hand, and making individual interpretations though in the style of the imitated artist. Still another method was to copy the original on the upper of two thin layers of paper, applying enough ink to soak through to the one beneath. One whole school achieved notoriety for its "old masters."

Around 1937, a first class artist ran a "transcript factory"—

139

chiefly to supply the insistent demands of Japanese officers for T'ang paintings. While attempting to conquer China, these military men had had their appetites whetted to acquire famed pictures for their homeland. The Chinese buried such replicas for a year or two to "age" them before marketing: "If they can't tell the difference, what does it matter?"

The excellence of all these forgeries resulted from the Sixth Canon of Painting, widely followed throughout China: "Carefully copy the old masterpieces." This practice intensifies the difficulty of identifying originals even for the most highly trained specialists. Experts rely on type of paper, weave of silk and kind of mounting; also on brush strokes—we have mentioned "wrinkles"—conventions for drawing the hands and feet, and on colophons and seals. Nevertheless often the most skilled appraisers cannot distinguish between the creator and the copyist. Has this dilemma not been equally true in the West? Did not Michelangelo copy his master's sketches and pass them off as originals? Nor was he discovered; his conscience finally forced the secret restoration of the genuine drawings. And in our own time, Vermigren's counterfeits deceived the public and might still do so, had not his excessive productivity aroused suspicion. And as of summer 1965, we read of one Durig who passed off close to a thousand drawings as Rodin's.[121] As recently as 1963, certain Modiglianis and Picassos were pronounced fake.

A dealer, it is said, took a signed painting to Picasso and asked if it was a genuine piece.

"Fake," grumbled Picasso.

The dealer then produced a second painting. Again the artist answered,

"Fake."

"But I myself saw you do this."

"I know, I paint many fakes," was Picasso's unperturbed reply.

CRITICS

The scholar and high official, Feng Yen[122] (about 780), in one of the first books of its kind on personal impressions, comments on travel and painting, wrote:

Wang Wei was particularly talented in landscape painting. His achievements in this line are unequalled. His work possesses the effect of great subtleness and profound calm. In this specialty no one in the past has attained to such heights. His artistic achievements are without peer.

Long after Wang Wei's death, as we have suggested, critics continued to refer frequently to his style of painting and to his prowess as a painter. They have used uncounted phrases to describe his over-all effects: ". . . he possessed special textual richness in the brushwork while still retaining a subtle reference to old tradition." Another commented upon his precise colouring; ". . . his grace of brush stroke and self-restraint in execution." Liu P'u[123] a poet and painter of the early eleventh century wrote, "I often said that Wang Mo-ch'i cut and polished his emotions in jade." Truly words which characterize the careful manner of Wang Wei's work.

Among the few dissenters to the general chorus of praise for Wang Wei, there were two prominent critics. Chang Yen-yüan in his "Record of Famous Paintings of all Dynasties,[124] classified all artists into various categories. But because he particularly admired Wu Tao-tzŭ, Chang placed him in the first rank of "Inspired Artists" with Wang Wei second among "Wonderful Artists." Chang did admit, nevertheless, that the order and refinement of Wang's technique exceeded Wu's.

The other dissenter, Chu Ching-hsüan[125] of the same period, believed that behind Wang's back his apprentices filled in the

141

master's outlines with colour and forged his seal. Chu also had the opinion that Wang's work was rough, sketchy and unfinished. He insisted further that when Wang concentrated on detail, he lost touch with the spirit. These contradictory comments are curious in view of the otherwise almost universal praise he received.

The first person who ever attempted landscape painting was Ku K'ai-chih (357–407), renowned for his remarkable versatility. Actually Ku used elements of landscape chiefly as stage setting for his "players." Su Tung-p'o, a leading statesman, poet and artist of the Sung Dynasty, went so far in his admiration for Wang Wei as to dare to denigrate the first maestro. According to Su, the only artist who could possibly pass the test of true greatness in this field was Wang Wei.

Su's praise of the only known fresco by Wang Wei was extraordinary. Contrasting it with one by the other contemporary "immortal," Wu Tao-tzǔ, Su writes that although both are peerless, Wang Wei has infused his work with his pure poetic instinct: He paints the students of Buddha gathered in the Jatavana Garden with both outer and inner reality. They "are as thin as cranes; in their hearts the passions are as dead as ashes and cannot be rekindled." The stark accompanying scenery forms an appropriate background. "Mo Ch'i reached beyond the shapes. He had the wings of an immortal to soar above the cage. . . . I saw the two (pictures); both were divinely beautiful—but as to Wang Wei, I retire in silence, without a word."[126]

No one has better understood Wang's genius than Su Tung-p'o; no one better explained it to posterity in several essays, most succinctly of all in his repeatedly quoted poem:

67. *Opposite page:* "Interpretation of Poem by Wang Wei," by Tung Ch'i-ch'ang (1555–1636), courtesy of Chang Dai-ch'ien, Brazil.

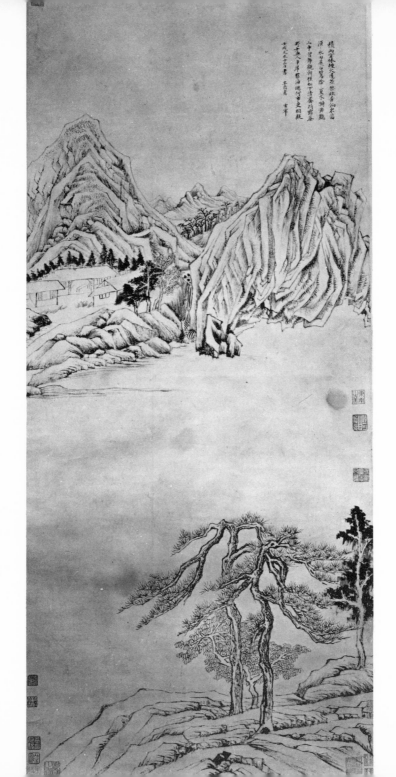

> *Hark to Mo-ch'i's odes, and you will behold his pictures.*
> *Look at Mo-ch'i's pictures, and you will hear his odes.*

To illustrate this colourful fusion, he quoted Wang Wei's own colourful poem, "In the Mountain":

> *White pebbles jut from the Blue River.*
> *Few red leaves remain in the cold weather.*
> *Though no rain soaked these mountain paths,*
> *Green mist moistens the traveller's clothing.*[127]

Wang Wei's "picture" poems were often translated into paint for succeeding artists. One by Mu Lin of the Southern Sung can be seen in the Cleveland Museum of Art: Emperor Li Tsung (1225–1264) honoured the scroll by adding two lines from Wang's poem.

Ten centuries after Wang Wei, Wang Hui, a noted painter of the Ch'ing Dynasty, chose as subject a frequently quoted verse, "My Hermitage in the Bamboo Grove:"

> *Deep in the bamboo grove, sitting alone,*
> *I thrum my lute as I whistle a tune.*
> *No one knows I am in this thicket*
> *Save the bright moon looking down at me.*[128]

Tung Ch'i-ch'ang illustrated another poem by Wang which belongs to the collection of China's leading present-day painter, Chang Dai-ch'ien, now in Brazil.[129]

Tung, himself a distinguished critic, wrote in a colophon:

The painters before Wang Wei were not lacking in skill only they could not transmit the spiritual quality of a landscape; they were still separated from this by a particle of dust (worldly thoughts).

In the same colophon, Tung compares Wang Wei with Wang Hsi-chih, the renowned calligraphist. He believed that as callig-

raphy was never the same after Wang Hsi-chih, so landscape painting was never the same after Wang Wei. Tung's critical estimate of Wang Wei included these words:

Wang Wei's landscapes are of the divine class. Men of former times . . . said that his cloudy peaks and beautiful rocks were superior to those of nature, and that he by his free manner of painting became as one with the creative power of Nature. He was the only man in the T'ang period.

Tung had long cherished an ambition to unearth a genuine Wang Wei. He heard of an original, "Clearing After Snowfall in the Mountains Along a River," owned by a man named Fêng Kung-shu:

I immediately asked a friend to go to Fêng and ask permission for me to borrow it. My friend went to his home. Fêng considered this picture to be a very early Wang Wei and valued it like his head, his eyes, or his brain. But when he heard that I had a great weakness for Wang Wei's paintings, he reluctantly granted my request. . . . But I refrained from opening it until I had abstained from human desire for three days.[130]

Then he closed his door, burned incense and clearing his mind of all other thoughts, prepared to unroll the scroll. When the great moment arrived and his eyes fell upon it he perceived at once—a genuine Wang Wei!

Then I felt the spirit of the mountains, the freshness of the streams and the mist over the spring gardens. I had never seen a genuine work by Wang before but had only thought of such in my heart. . . . I slept little for some days, for I felt that I had actually entered Wang Wei's studio and seen his hand guiding the brush.

Tung adds finally, "Truly it was Mo-ch'i's purified spirit blended with water and ink which created this priceless treasure."

According to a colophon written by the owner of the scroll, 145

Fêng Kung-shu, this Wang Wei came to light when an old house at the Hou-chai Gate, Peking, was torn down. In a broken bamboo tube serving as a door bolt, there were two other scrolls also from the T'ang and Sung Dynasties. Immediately curious about those, he asked might they not also be paintings by Wang Wei? No, Fêng said one was by Wang Hsi-chih, the famous calligraphist, and the other by someone named Yü. The possibility of seeing a scroll by the fomer excited Tung enormously: "If I could get them together, it would be perfect," he said. "I would see at the same time the best painting and the best calligraphy." No one knew what had become of the other two scrolls. Sorrowfully Tung exclaimed, "Isn't it the jealousy of 'The Old Man in Heaven' to deny me this perfect fulfilment, and let me see only this one scroll to enjoy!"

Eight centuries after Wang's death, Tung Ch'i-ch'ang and another leading critic, Mo Shih-lung, took it upon themselves to divide all landscape painters past and present into two schools, the Northern and the Southern. They honoured Li Ssŭ-hsün with the title of Founder of the Northern School and Wang Wei of the Southern. These critics chose the two ancient eminent names in order to bolster their authority for their own predilections. They invented a heritage for the artists of each school, an "apostolic" succession of masters descending from each founder.

As far back as the Sung Dynasty (960–1278), art critics had already perceived that Chinese landscape painting was evolving into two distinct styles, one of rugged grandeur, the other of gentle mystical beauty. Let one Chinese writer, Hsiao Hua-pien, explain:

Meteorological phenomena differ according to localities; so in like manner man's nature differs according to places of habitation. Consequently men born in the South, with its mild and graceful scenery are subject to influences either good or bad, being liable to become either genteel and refined, or light-hearted and insincere. On the other

68. "Fair Weather After Snowing," calligraphy by Wang Hsi-chih.

hand, they who are reared amidst the grand and majestic landscapes of the North will, if rightly directed, become manly and powerful, but otherwise they are apt to turn rude and unbridled. Such is the natural order of things, and it is nothing strange that art itself is divided into the two separate schools of the North and South, according as pictures are done in conformity with the characteristic nature of the Southerners or with that of the Northerners.[131]

Of course such a division is artificial—any artist might use two or more styles of painting. By and large, the work of the Northern School is supposed to exhibit much more detail than the Southern.[132] A Northern artist might take a year to paint his masterpiece; the Southern one with more simplicity might finish his in a

147

month or even in a day. With a few bold strokes, he could suggest vast distances emphasized by a small sage sitting beneath a tangled fir tree in contemplation.

The one school insisted on realism, the other emphasized emotion. The intellect guided one, intuition the other. One applied strong colour almost pure, the other often used ink alone. There are other ways of describing these schools; such as extrovert versus introvert or characterized by powerful, unpedantic brush strokes versus strokes self-conscious, taut, contrived or studied. A classic sublimity informs the mountain ranges and far-reaching plains of the Northern art: a romantic picturesqueness, the rivers and gorges of the Southern School. According to Binyon, the two schools reflect the opposing temperaments—the tough-minded versus the tender-minded.

In A.D. 1488, Shen Chou writes delightedly of the "tender-minded"work of a "heaven born genius," Wang Wei:

On this warm summer day I have betaken myself to a priest's secluded cell, and here good fortune has guided my eyes to a scroll . . . one of Wang Wei's landscapes depicting a snow scene, the very essence of which, with its pines and willows and the graceful bamboos, wafts a gentle zephyr of coolness through the heated air. Boats are seen moored by the banks with idle oars, while the world sleeps, for it is the hour of daybreak and nature is in her calmest mood. A flock of crows fly confusedly against a sudden breath of the western wind and the wild geese journey on unceasingly.

Though the picture is lightly drawn in grey tones, its pervading spirit breathes life—it is a masterpiece of light and shade combined: its rare strokes are graceful and delicate, yet bold and firm where necessary. The scenery is . . . the southern portion of the Yangtze-kiang and the style is of the "three distances." . . . To gaze upon its perfection . . . is a rare and priceless opportunity which has been auspiciously afforded me in my closing years.

148 Sullivan thinks that Wang's reputation as Founder of the South-

ern School is owing to ". . . his all-round genius as a great artistic personality."[133]

Among the established authorities of Wang's Western critics we shall name only a few: Waley, Ferguson, Cohn, Siren, Sullivan, Birch, Munsterburg, Lee, Sickman and Soper. They seem to agree that Wang Wei is the true father of landscape painting in China and the first illustrious scholar-poet-painter.

Waley qualifies Wang as the progenitor of landscape with the one exception of "those who used archaistic style in green, blue and gold."[134]

Ferguson thinks Wang Wei's style completely dominated subsequent landscapists. This author states that Wang Wei quite overshadowed Li Ssŭ-hsün and that (as we also have said) Li owed his eminent position mainly to imperial connections.[135]

Sickman and Soper,[136] on the other hand, question Wang's creation of a completely new style of painting, but agree to the possibility of his making "landscape a more fluid vehicle for expression."

Cohn believes Wang shed glory on the mid-T'ang Dynasty and set standards for later painters. Wang became the esoteric idol of the man of high culture by his scholar-painter style.[137]

According to Siren, Wang Wei "bridged the old with the new," occupying an intermediate position in the history of landscape painting. His illustrative elements show keen observation and careful execution. Integrated into a complete composition, they possess both formal and pictorial unity—not "strung together or displayed in more or less decorative combinations." The vision of Wang Wei has a wider range than that of earlier masters: He penetrates deeper into nature and transmits his observations with individual accents.[138]

Sullivan says of Wang that ". . . in him the literary and artistic traditions fuse together. He is the first great scholar-poet who was also a painter, the forerunner of the *wên-jên-hua,* which has played

149

so prominent a part in Chinese painting since the Yüan Dynasty."[139]

Birch claims: "In painting and poetry alike he made more than a record or interpretation of nature: he achieved perhaps the closest union with the natural world that has ever been expressed."[140]

Munsterberg sees a link between the eighth century style of men like Wang Wei and the better landscapists of the tenth century. He may mean that some touch of Wang Wei's brush still lingers in such giants as Ma Yüan, Mi Fei and others.[141]

To quote Lee of the Cleveland Museum of Art:

He is reputed to have been not only one of the greatest of landscape painters but to have pioneered in monochrome landscape painting. . . . It was certainly Wang Wei, judging from the evidence of remaining stone engravings who "invented," landscape per se.

The scroll painting of his country estate called *Wang Ch'uan* is the first true Chinese landscape. Where figures do occur, they are incidental; the landscape itself is the subject of the picture.[142]

Above all others, Wang is accredited with the first pure landscape in history. He mines the very essence of it at a deeper level than any predecessor. He sees scenic beauty through the unfettered eyes of the poet; he sings in clear, unmistaken melody his own interpretation of the universal melody.

As timeless as the hills he painted, Wang Wei's masterpieces belong as much to our day as to the eighth century—so far as we can judge from copies, those copies jealously guarded by museums throughout the world. Each curator secretly hopes that his priceless scroll "in the manner of Wang Wei" be not too far "after Wang Wei"; that it posesses at least the aura of that Chinese genius.

More than a thousand years have elapsed since Wang Wei lived out his official and court life in Ch'ang-an, the City of Eternal Peace. The ancient capital has long since disappeared. Today, a

bustling modern city hides the old site—Si-an, Western City of Peace.

Wang Wei lived out his private and preferred life at Wang Ch'uan, his heart home, the source of his greatest inspiration. There, in that romantic old villa he relaxed with his comrades in fertile discussion and light-hearted verse making. There, under a bright moon, he and his favourite companion, P'ei Ti, wandered in the foothills together, full of wine and laughter. There, as we know, he created his compelling pictures, wrote much of his poetry and sang his songs. His pictures have all but vanished. The songs have faded to echoes, the echoes to silence. But those lyrics, once set to music, and those poems are not wholly lost. They fill volumes, carefully preserved in all the main Chinese libraries.

As for Wang Wei, himself, he lives on secure in the immortality of genius.

> *There, white clouds sail on forever*
> *without exhausting time.*

BIBLIOGRAPHY

BOOKS IN ENGLISH

ACKER, WILLIAM. Tr. *Some T'ang and Pre-T'ang Texts on Chinese Painting*. Leiden: E. J. Brill, 1954. Pp. lxii+414.

AYSCOUGH, FLORENCE. *Travels of a Chinese Poet Tu Fu Guest of Rivers and Lakes*. London: Jonathan Cape, 1934. Pp. 350.

AYSCOUGH, FLORENCE. *Tu Fu The Autobiography of a Chinese Poet*. London: Jonathan Cape, 1929. Pp. 450.

BACHHOFER, LUDWIG. *A Short History of Chinese Art*. New York: Pantheon Books Inc., 1946. Pp. 139+Pl. 129.

BINYON, LAURENCE. *Painting in the Far East*. New York: Dover Publication, Inc., Third Edition 1959. Pp. xx+297.

BIRCH, CYRIL. Ed. *Anthology of Chinese Literature*. New York: Grove Press, Inc., 1965. Pp. xxxiv+492.

CAHILL, JAMES. *Chinese Painting*. Cleveland: The World Publishing Company (Albert Skira, Geneva), 1960. Pp. 213.

CARTER, DAGNY. *Four Thousand Years of China's Art*. New York: The Ronald Press Company, 1948. Pp. xix+358.

CHANG YIN-NAN and WALMSLEY, LEWIS C. Tr. *Poems by Wang Wei*. Rutland, Vermont: Charles E. Tuttle Company, Seventh Printing 1966. Pp. 159.

153

CHEN SHIH-HSIANG. Tr. *Biography of Ku K'ai-chih*. Chinese Dynastic Histories Translations. Berkeley and Los Angeles: University of California Press, 1953. Pp. 31.

CHIANG YEE. *Chinese Calligraphy*. London: Methuen & Co. Ltd., 1938. Pp. xiv+230.

CHIANG YEE. *The Chinese Eye*. London: Methuen & Co. Ltd., 1960. Pp. xvi+239.

COHN, WILLIAM. *Chinese Painting*. London: Phaidon Press Ltd., 1948. Pp. 224+12 indexes and lists of plates.

DRISCOLL, LUCY, and TODA, KENJI. *Chinese Calligraphy*. Chicago: The University of Chicago Press, 1935. Pp. vii+71.

FAIRBANK, JOHN K. Ed. *Chinese Thought and Institutions*. Chicago: University of Chicago Press. 1957. Pp. xi+427.

FEI CH'ENG-WU. *Brush Drawing in the Chinese Manner*. London and New York: The Studio Productions, 1957. Pp. 95.

FERGUSON, JOHN C. *Chinese Painting*. Chicago: The University of Chicago Press, 1927. Pp. ix+199.

FITZGERALD, C. P. *The Empress Wu*. London: The Crescent Press, 1956. Pp. xii+252.

GILES, HERBERT A. *History of Chinese Pictorial Art*. London: Bernard Quartich, 1918. Pp. viii+218.

GOEPPER, ROGER. *The Essence of Chinese Painting*. Boston: Boston Book and Art Shop, 1963. Pp. 244.

THE GOVERNMENT OF THE REPUBLIC OF CHINA. Ed. *Chinese Art Treasures*. Taipei, Taiwan: 1961–62. Pp. 286. Produced by Albert Skira, Geneva, Switzerland.

GROUSSET, RENE. *Chinese Art and Culture*. New York: The Orion Press, 1959. Pp. xxii+331.

HIRTH, FRIEDRICH. *Scraps From a Collector's Note Book*. New York: G. E. Stechert & Co., Reprint 1924. Pp. 136.

HUNG, WILLIAM. *Tu Fu, China's Greatest Poet*. Cambridge, Massachusetts: Harvard University Press, 1952. Pp. x+300.

Illustrated Catalogue of Chinese Government Exhibits for the Inter-

154

national Exhibition of Chinese Art in London. Four Volumes. Shanghai: Volume III, *Painting and Calligraphy,* n.d. Pp. 259.

INSTITUTE OF CHINESE CULTURE. *Chinese Art Treasures.* Series A. Volume 4. Taipei: United Publishing Center, n.d. Pp. 50.

JENYNS, SOAME. *A Background to Chinese Painting.* London: Sidgwick & Jackson, Ltd., 1935. Pp. xxviii+209.

JOSEPHSON, ERIC AND MARY. *Man Alone.* New York: Dell Publishing Co., Inc., 1962. Pp. 592.

LATOURETTE, KENNETH SCOTT. *The Chinese Their History and Culture.* New York: The Macmillan Company, 1946. Third Edition. Pp. xvi+847.

LEE, JAMES ZEE-MIN. *Chinese Potpourri.* Hong Kong: The Oriental Publishers, 1950. Pp. 331.

LEE, SHERMAN E. *A History of Far Eastern Art.* New York: Harry N. Abrams, Inc., n.d. Pp. 527.

LEE, SHERMAN E. *Chinese Landscape Painting.* New York: Harry N. Abrams, Inc., n.d. Second Edition. Pp. 159.

LEVY, HOWARD S. Tr. *Biography of Huang Ch'ao.* Chinese Dynastic Histories Translations. Berkeley and Los Angeles: 1955. Pp. 144.

LEVY, HOWARD S. Tr. *Biography of An Lu-shan.* Chinese Histories Translations. Berkeley and Los Angeles: 1960. Pp. 122.

LEVY, HOWARD S. *Harem Favorites of an Illustrious Celestial.* Taichung: Chung-T'ai Printing Company, Ltd., 1958. Pp. xiii+196.

LIN YUTANG. *The Gay Genius, The Life and Times of Su Tungpo.* New York: The John Day Company, 1947. Pp. xi+427.

LIN YUTANG. *Lady Wu.* New York: G. P. Putman's Sons, 1965. Pp. 255.

MARCH, BENJAMIN. *Some Technical Terms of Chinese Painting.* Baltimore: Waverly Press, 1935. Pp. xiii+55+vii Plates.

DE MORANT, GEORGE SOULIE. *The Passion of Yang Kwei-fei.* New York: Covici, Friede, 1928. Pp. 200.

155

MUNSTERBERG, HUGO. *The Landscape Painting of China and Japan*. Rutland, Vermont: Charles E. Tuttle Company, 1935. Pp. xv+144+101 Plates.

PETRUCCI, RAPHAEL. *Chinese Painters*. New York: Brentano's, 1920. Pp. v+155.

PULLEYBLANK, EDWIN G. *The Background of the Rebellion of An Lu-shan*. London: Oxford University Press, 1955. Pp. vii+264.

REISCHAUER, EDWIN O. Tr. *Ennin's Travels in T'ang China*. New York: The Ronald Press Company, 1955. Pp. ix+341.

RIENCOURT, AMAURY DE. *The Soul of China*. New York: Coward-McCann, Inc., 1958. Pp. xx+298.

ROWLEY, GEORGE. *Principles of Chinese Painting*. Princeton: Princeton University Press, 1947. Pp. x+111+47 Plates.

SAKANISHI, SHIO. Tr. *The Spirit of the Brush*. London: John Murray (The Wisdom of the East Series), 1939. Pp. 108.

SAKANISHI, SHIO. Tr. *An Essay on Landscape Painting,* by Kuo Hsi. London: John Murray (The Wisdom of the East Series), 1936: Pp. 64.

SAUNDERS, KENNETH. *A Pageant of Asia*. London: Oxford University Press, 1934. Pp. xv+452.

SICKMAN, LAURENCE and SOPER, ALEXANDER. *The Art and Architecture of China*. Harmondsworth, Middlesex: Penguin Books, Ltd., 1956. Pp. xxvi+334.

SIREN, OSVALD. *The Chinese on the Art of Painting*. Peiping: Henri Vetch, 1936. Pp. 261.

SIREN, OSVALD. *Chinese Painting*. (Seven Volumes) New York: The Ronald Press Company, 1956. Vol. I. Pp. xi+235. Vol. III. Pp. xviii+Pl. 372+14.

SIREN, OSVALD. *A History of Early Chinese Painting*. (Two Volumes) London: The Medici Society, 1933. Vol. I. Pp. xxii+138. Pl. 100. Vol. II. Pp. ix+161+Pl. 126.

SOOTHILL, WILLIAM EDWARD. *The Hall of Light*. London: Lutterworth Press, 1951. Pp. xxii+289.

SOPER, ALEXANDER COBURN. Tr. *Kuo Jo-Hsü's Experiences in Painting, Tu-hua Chien-wen chih*. Washington, 1951. Pp. xii+216+ Chinese Text.

SPEISER, WERNER. *China*. London: Methuen, 1960. Pp. 256.

STREHLNECK, E. *Chinese Pictorial Art*. Abe Fusajiro, Soraikan Kinsho. Shanghai: The Commercial Press, 1914. Pp. 323+Pl. 73.

SULLIVAN, MICHAEL. *The Birth of Landscape Painting in China*. Berkeley: University of California Press, 1962. Pp. xvii+213+ 151 Plates.

SULLIVAN, MICHAEL. *An Introduction to Chinese Art*. Berkeley: University of California, 1961. Pp. 223+449 Plates.

SWANN, PETER C. *Art of China, Korea, and Japan*. New York: Frederick A. Praeger, 1963. Pp. 285.

SWANN, PETER C. *Chinese Painting*. New York: Universe Books, Inc., 1958. Pp. 155.

SZE MAI-MAI. *The Tao of Painting*. Tr. *Chieh Tzŭ Yüan Hua Chuan*. New York: Pantheon Books Inc., 1956. Pp. Volume I xxii+161; Volume II, xxxv+587.

UNDERHILL, EDNA WORTHLEY and CHI HWANG CHU. *Tu Fu Wanderer and Minstrel*. Portland, Maine: The Mosher Press, 1929. Pp. liv+247.

VAN BRIESSEN, FRITZ. *The Way of the Brush*. Tokyo: Charles E. Tuttle Company, 1962. Pp. 329.

VAN GULIK, R. H. *Sexual Life in Ancient China*. Leiden: E. J. Brill, 1961. Pp. xvii+391.

WALEY, ARTHUR. *An Introduction to the Study of Chinese Painting*. New York: Grove Press Inc., 1923. Reprinted 1958. Pp. xii+ 262+49 Plates.

WALEY, ARTHUR. *The Life and Times of Po Chü-i*. London: George Allen and Unwin Ltd., 1949. Pp. 238.

WALEY, ARTHUR. *The Poetry and Career of Li Po*. London: George Allen and Unwin Ltd., 1950. Pp. xi+123.

WALEY, ARTHUR. Tr. *The Way and Its Power (Tao Tê Ching)*. London: George Allen & Unwin Ltd., Reprinted 1949. Pp. 262.

WANG, ELIZABETH TE-CHEN. Tr. *Ladies of the T'ang*. Taipei: Heritage Press, 1961. Pp. xi+347.

WU, Mrs. LIEN-TEH. *The Most Famous Beauty of China*. New York: D. Appleton and Company, 1924. Pp. xv+117.

MAGAZINE ARTICLES

BURLING, JUDITH and ARTHUR. "Contemporary Chinese Painting." *Magazine of Art,* Washington. Vol. XLII, No. VI, (October 1949). Pp. 221–226.

DUBOSE, J. P. "A New Approach to Chinese Painting." *Oriental Art,* London. Vol. III, No. II, (1950). Pp. 50–57.

FERGUSON, JOHN C. "Wang Ch'uan." *Oastasiatische Zertschraft,* Vol. III. Pp. 51–60.

FRANKE, HERBERT. "Wang-Ch'uan Chi." *Oastasiatische Zertschraft,* Vol. XXIII, (1937). Pp. 76.

THE INSTITUTE OF ARCHAEOLOGY, ACADEMIA SINICA, Ed., "Ta Ming Kung of the T'ang Capital Ch'ang-an." *Science Press,* Peking. (1959) Pp. 66+Plates 72.

LAUFER, BERTHOLD. "The Wang Ch'uan T'u, a Landscape by Wang Wei." *Oastasiatische Zertschraft*. Vol. I, (1912), Pp. 28–55.

LI LIEN-TSAN. "Examples of Periodic Change in Chinese Painting." *Bulletin of the Institute of History and Philosophy, Academia Sinica,* Taipei. Extra Vol. IV, Pt. II, (1961). Pp. 463–1017.

MACDONALD-WRIGHT, STANTON. "Some Aspects of Sung Painting." *Magazine of Art,* Washington. Vol. XLII, No. 6, (October 1949). Pp. 221–226.

Oriental Art. A Quarterly Publication. London: The Oriental Art Magazine Ltd., 125 High Holbom, London, W.C.1.

POPE, ARTHUR A. "The Art Tradition." *Harvard Journal of Asiatic*

Studies, Cambridge. (December 1947).

Peking Review, Peking. "Ancient Classical Paintings." Vol. III, No. 46, (November 15, 1960). Pp. 22–24.

SIREN, OSVALD. "The Expressionism of Chinese Painting." *East and West,* Rome. Vol. IV, No. 3, (October 1953). Pp. 184–190.

SOPER, ALEXANDER C. "T'ang Ch'ao Ming Hua Lu." *Artibus Asiae.* Vol. XXI, 3/4 Separatum, (1948). Pp. 204–230.

BOOKS IN CHINESE

Chin T'ang Er Ta Hua Chia, by WEN CHAO-T'UNG. Shih Chieh Book Co., Shanghai, 1945. 晋唐二大畫家，温肇桐著

Ch'ing Ho Shu Hua Fang, by CHANG CH'OU. Completed about A.D. 1616. Sao-yeh Shan Fang Ts'ung Shu Edition. 清河書畫舫，張丑撰

Chiu T'ang Shu, by LIU HSÜ (887–946) and others. Po-na Edition. 舊唐書，劉昫等撰

Chung Kuo Hua Lun Lei Pien, by YÜ CHIEN-HUA. Chung Kuo Hu-tien I-shu Press, Peking, 1956. 中國畫論類編上，下冊，兪劍華編著

Chung Kuo Hui Hua Shih, by YÜ CHIEN-HA. Commercial Press, Second Edition, Shanghai, 1954. 中國繪畫史上，下冊，兪劍華著

Chung Kuo Shan-shui Ha Ti Nan Pei Tsung Lun, by YÜ CHIEN-HA. Jen-min Mei-shu Press, Revised Edition, Shanghai, 1961. 中國山水畫的南北宗論，兪劍華著

Feng Shih Wen Chien Chi, by FENG YEN (fl. 800). In Ya Yü T'ang Tsung Shu, 1756. 封氏聞見記，封演撰

Hsin T'ang Shu, by OU-YANG HSIU (1007–1072) and others. Po-na Edition. 新唐書，歐陽修等撰

Hsüan Ho Hua P'u, Imperial Collection of Northern Sung. Completed in 1120. Ts'ung Shu Chi Ch'eng Edition. 宣和畫譜，上，下冊

159

Hua Shih, by MI FEI (1051–1107). Tsung Shu Chi Ch'eng Edition. 畫史, 米芾撰

Li Tai Ming Hua Chi, by CHANG YEN-YÜAN. Completed in A.D. 847. Ts'ung Shu Chi Ch'eng Edition. 歷代名畫記, 張彥遠撰

T'ang Ch'ao Ming Hua Lu, by CHU CHING-HSÜAN. Completed about A.D. 840. Tsung Shu Chi Ch'eng Edition. 唐朝名畫錄, 朱景玄撰

T'u Hua Chien Wen Chih, by KUO JO-HSÜ. Completed about A.D. 1074. Tsung Shu Chi Ch'eng Edition. 圖畫見聞誌, 郭若虛撰

T'ang Sung Hua-chia Jen-ming Tz'u-tien, by CHU CHU-YÜ. Chung Kuo Ku-tien I-shu Press, Peking, 1958. 唐宋畫家人名辭典, 朱鑄禹編

T'ang Sung Hui-hua T'an-tsung, by T'UNG SHU-YEH. Chung Kuo Ku-tien I-shu Press, Peking, 1958. 唐宋繪畫談叢, 童書業著

T'ang Sung Hui-hua Shih, by T'ENG KU. Shen Chou Kuo Kuang Press, Shanghai, 1933. 唐宋繪畫史, 滕固著

T'ang Tai Chang-an Yü Hsi-yü Wen Ming, by HSIANG TA. San Lien Book Press, Peking, 1957. 唐代長安與西域文明, 向達著

T'ang Tai Shih-ko, by WANG SHIH-CH'ING. Jen-min Wen-hsüeh Press, Peking, 1959. 唐代詩歌, 王士青著

T'ang Tai Wen-hua Shih Yen-chiu, by LO HSIANG-LIN. Commercial Press, Shanghai, 1946. 唐代文化史研究, 羅香林著

Wang Ch'uan Chih, by HU YUAN-YING. Revised Edition, 1839. 輞川志, 胡元煐重刊

Wang Yu-ch'eng Chi Chien Chu, by CHAO TIEN-CH'ENG. Reprinted by Chung-hua Shu-chü, Shanghai, 1961. 王右丞集箋注, 趙殿成

160

LIST OF PAINTINGS

EMPEROR HUI TSUNG'S CATALOGUE
ELEVENTH CENTURY

Said to contain 128 paintings attributed to Wang Wei. Sixty-nine of these were of Buddhist figures, forty-eight of the Lohan, Pratyeka Buddha. Some Taoist figures.

PORTRAITS AND FIGURES

Four full portraits of Vimalakirti.
Two portraits of Wang Wei's cousin, Ts'ui.
Mêng Hao-jen Reading the Classics on Horseback.
Master Fu Shêng Engaged in Restoring the Text of the *Shu Ching*.
Two Scholars Playing Chess, inscription in style of Emperor Hui Tsung.
Western Ambassador Paying Tribute to T'ang Court.
Reading, *K'an Shu T'u*.
A Fish Market.
Strange Nations.
The Return of the Sage to His Country Home.

Fishing in a Stream in Spring.
Shouting for the Ferryboat.

SNOW SCENES

Snow Scene, *Hsüeh T'u or Hsüeh Ching.*
Snow by the River. *Hsüeh Chiang T'u.*
Mount Lan in Snow, *Hsüeh Lan T'u.*
Snow piled up on a Thousand Peaks.
Mountain Cottage in Snow.
Bidding Farewell in Snow.
Angling in Snow.
Snow by the Ford, *Hsüeh Hsi T'u.*
Hills by the River After Snow.
The Pa Bridge in a Snowstorm
A Banana in Snow.
Snow Over the Mountain Stream.
A Snowy Valley, *Hsüeh Hu T'u.*
Falling Snow on the River, *Chiang Kan Hsüeh Chi.*
Clearing After Snowfall in the Mountains Along the River,
 Chiang Shan Hsüeh Chi T'u.
Clearing After Snowfall on the Mountains, *Kuan Shan Chi
 Hsüeh T'u.* (This may be from a copy of the above painting.)

LANDSCAPES

Wang Ch'uan Scroll, *Wang Ch'uan T'u.*
Landscape View of Wang Ch'uan and Chuang Villa.
The Village at the Lake on a Bright Day.
River Landscape with a Boat in Winter.
Waterfall.

Sharply Outlined Mountains and Bare Trees by a River in Snow.

Fragment of a Handscroll, Pine Trees Bending over a River.

OTHERS

Standing Screen with Maple Leaves in Ch'ien Fu Ssŭ.

Frescoes in Buddhist Temples at Ts'u-ên Ssŭ and Ching Yuan Ssŭ, in Ch'ang-an.

Fresco in Eastern Wing of K'ai Yüan Temple at Fêng Hsiang.

A number of Bamboo Paintings.

NOTES

¹ Binyon, *The Flight of the Dragon*, p. 8.

² Wang Wei, b. 701; Li Po, b. 701; Tu Fu, b. 712.

³ *Hsing Ch'ing Kung.*

⁴ *Sterculia platanifolia:* commonly, wood-oil trees.

⁵ *T'ai Chi Kung.*

⁶ *Huang Ch'eng.*

⁷ *Ta Ming Kung.*

⁸ *Li Yüan.*

⁹ Other versions: the tower commemorates the "Twenty-four Founding Knights" who helped Emperor T'ai Tsung establish the Dynasty.

¹⁰ *Peking Review,* January 20, 1961, pp. 23–24.

¹¹ For a description of recent excavations at the palace site see Lu Chao-yin, "The T'ang Capital Unearthed." *China Reconstructs,* XIV, (January, 1965), pp. 36–39.

¹² *Poems by Wang Wei,* No. 113.

¹³ *Ta T'ung Tien.*

¹⁴ It has been suggested that Li Ssŭ-hsün's son, Li Chao-tao might have painted beside Wu Tao-tzŭ.

¹⁵ *Ching Yün Ssŭ.*

¹⁶ Jenyns, *A Background to Chinese Painting,* p. 64.

¹⁷ Designed presumably by the artist, Yen Li-pên.

¹⁸ *Wen Ch'uan,* at Hua Ch'ing Kung.

¹⁹ *Poems by Wang Wei,* No. 101.

[20] *Ch'en Hsiang Ting*—Lign-Aloes, an aromatic wood found in China, also in Mexico.

[21] About equivalent to fifteen thousand dollars, American currency.

[22] In T'ang times, a peck of rice normally sold for about 20 cash; in war years for about 7000 cash; in the 1920's, 2500 cash, or about 30 cents, American currency.

[23] According to Chen Chung-mien in *History of Sui and T'ang Dynasties,* China's population in 755 was 52,919,309! The day and hour of this census is not recorded.

[24] *Poems by Wang Wei,* No. 141.

[25] *Poems by Wang Wei,* No. 100.

[26] *Ta Yen T'a.*

[27] In 701, only fifteen hundred students from the whole of China were selected to write the Imperial Examinations. In 715, Chang Chiu-lin stated that of ten thousand students only one hundred passed.

[28] *Poems by Wang Wei,* No. 123.

[29] Festival of the Ninth-Day-of-the-Ninth-Moon, the Festival of Ascending High Mountains. Sprigs of dogwood to drive away evil spirits. *Poems by Wang Wei,* No. 52.

[30] *Poems by Wang Wei,* No. 123.

[31] Chinese characters.

[32] *P'i-pa:* A guitar-like instrument introduced by foreigners from Kuei Tzŭ (Kuchah) in northern Sinkiang Province.

[33] *Poems by Wang Wei,* No. 22.

[34] First place in the Provincial Examinations.

[35] *Ta Yüeh Ch'eng.*

[36] *Poems by Wang Wei,* No. 55.

[37] From *Tso Commentary.*

[38] *Poems by Wang Wei,* No. 26.

[39] *Ssu Ts'ang Ts'an Chün.*

[40] *Poems by Wang Wei,* No. 109.

[41] *Poems by Wang Wei,* p. 140.

[42] *Yü Shih I.*

[43] *Chung Shu Sheng.*

[44] *Chien Ch'a Yü Shih.*

[45] *Yu Shih T'ai.*

[46] *Poems by Wang Wei,* Nos. 40, 41, 58, etc.

[47] *Poems by Wang Wei,* No. 45.

[48] *Poems by Wang Wei*, No. 129.

[49] *Pu Ts'ai Ming Chu Ch'i.*

[50] *Poems by Wang Wei*, No. 36.

[51] *Chao Yeh Pai.*

[52] *Kuang Wên Kuan.*

[53] First to *Tso Po Ch'üeh*, then to *K'u Pu Lang Chung.*

[54] *Poems by Wang Wei*, No. 113.

[55] *Poems by Wang Wei*, pp. 29–30.

[56] This "three years" period was contracted to the remaining part of the year of death, the following year and one month in the third year.

[57] Ayscough, *Tu Fu The Autobiography of a Chinese Poet*, pp. 313–314.

[58] *Chi Shih Chung.*

[59] *Ning Pi Ch'ih.*

[60] *P'u T'i Ssŭ.*

[61] *Poems by Wang Wei*, No. 65.

[62] *Shang Shu yu Ch'eng.*

[63] An approximate translation, slightly rearranged.

[64] *Ch'ing Yüan Ssŭ.*

[65] *Shu Hua Chi.*

[66] Same Romanization, different characters.

[67] One of Chinese earliest classics describing the way in which *Tao* operates.

[68] See Siren, *Chinese Painting*, Vol. 1, p. 5. Also, van Briessen, *The Way of the Brush*, pp. 109–111.

[69] *Poems by Wang Wei*, No. 107.

[70] *Li Tai Ming Hua Chi.*

[71] Sakanishi, *An Essay on Landscape Painting, by Kuo Hsi*, p. 31.

[72] Sakanishi, *The Spirit of the Brush*, p. 36.

[73] Sakanishi, *An Essay on Landscape Painting*, p. 35.

[74] Waley, *An Introduction to the Study of Chinese Painting*, pp. 193–4.

[75] A universal concept not closely related to the religion of Taoism.

[76] *Time Magazine*, April 3, 1964, p. 77.

[77] Soper, *Kuo Jo-hsü's Experiences in Painting*, p. 81.

[78] Modern psychologists claim that man today has lost the sense of belonging to nature due to "the separation of man from the objective world." See Moustakas, *Loneliness*, p. 26.

[79] de Riencourt, *The Soul of China*, pp. 34–38.

[80] China was divided into three separate kingdoms from 221 to 265.

[81] Fei Cheng-wu, *Brush Drawing,* p. 19.

[82] Arthur Waley, *An Introduction to the Study of Chinese Painting,* p. 149.

[83] *Poems by Wang Wei,* No. 34.

[84] Mi Fei in *Hua Shih.*

[85] Petrucci, *Chinese Painters,* p. 30.

[86] *Tao Tê Ching,* No. 12.

[87] *Chu P'u.*

[88] From *Wang Chin's Collection,* p. 547.

[89] Siren, *Chinese Painting,* Vol. 1, p. 128.

[90] *Chieh Tzŭ Yüan Hua Chuan, Ho-yeh-ts'un.*

[91] *Chieh Tzu Yüan Hua Chuan,* Vol. III, p. 15, Miss Sze's translation in *The Tao of Painting,* p. 156.

[92] *Chieh Tzŭ Yüan Hua Chuan,* Vol. III, p. 29, Miss Sze's translation in *The Tao of Painting,* p. 205.

[93] Quoted in Saunders, *Pageant of Asia,* pp. 316–317.

[94] *Poems by Wang Wei,* p. 23.

[95] See, Cohn, *Chinese Painting,* p. 51.

[96] According to *Wang Yu-ch'eng Chi Chien Chu,* p. 526, originally a twenty-three foot scroll.

[97] Although Ku K'ai-chih's famous *"Admonitions"* and Lu Hung's *"Ten Views From a Thatched Cottage"* were earlier, they incorporated a number of more or less independent pictures. Wang Wei's painting portrayed one continuous unfolding landscape.

[98] *Poems by Wang Wei,* Nos. 1–20.

[99] Laufer, "The Wang Ch'uan T'u," *Oastasiatesche Zertschraft,* I (1912), p.55.

[100] See, Binyon, *Painting in the Far East,* p. 91.

[101] Bachhofer, L., *A Short History of Chinese Art,* p. 105.

[102] *Wang Yu-ch'eng Chi Chien Chu,* Vol. II, p. 527.

[103] *Wang Yu-ch'êng Chi Chien Chu,* Vol. II, p. 527.

[104] Laufer, "Wang Ch'uan T'u, A Landscape by Wang Wei," *Oastasiatesche Zertschraft,* I (1912), pp.528-55.

[105] Binyon, *Painting in the Far East,* p. 91.

[106] Some have suggested by Yen Wen-kui of the Sung Dynasty.

[107] Its origin is open to question. According to one, the work of Wen Cheng-ming (1470–1559); Dr. Ho Wai-kam believes it a Northern Sung painting after the Li Lung-men version, perhaps the only

version of Li Lung-men in existence today, as such very important.

[108] Hirth claims to have obtained a copy of "Bananas in the Snow" in 1893. Reproduced in his, *Scraps From a Chinese Note Book.*

[109] See van Briessen, *The Way of the Brush*, p. 121.

[110] See Cohn, *Chinese Painting*, p. 51, footnote.

[111] Cohn, *loc, cit.*

[112] *Hsüeh Chiang T'u.*

[113] Hsüeh Hsi T'u.

[114] *Hsüeh T'u,* Reproductions in *Works of Famous Chinese Artists,* Vol. XXIII. Also, Siren, *Chinese Painting,* Vol. III, Plate 97.

[115] *Harvard Journal of Asiatic Studies,* December 1947, p. 411.

[116] *K'an Shu.*

[117] *Hsüeh Ching.*

[118] *Hsueh Lan T'u,* Reproduction No. 28 in a series of Albums edited by Tseng K'an.

[119] According to C. C. Shih, read *Wan Feng Hsüeh Chi T'u,* as "Ten thousand peaks snow clearing! Ten thousand springs. . . ."

[120] *Wang Yu-ch'eng Ch'i Chien Chu,* Vol. II, p. 523.

[121] *Life Magazine,* June 4, 1965, p. 69.

[122] Feng Yen, *Feng Shih Wen Chien Chi,* Vol. V, p. 65.

[123] Liu P'u (*c.* 965–1026) Poet and painter, a recluse near West Lake in Hang-chou. Discarded poems and pictures on completion, not caring for fame. Giles, *Biographical Dictionary,* 1258.

[124] *Li Tai Ming Hua Chi* (A.D. 847).

[125] *Famous Paintings of the T'ang Dynasty,* "T'ang Ch'ao, Ming Hua Lu."

[126] Siren, *Chinese Painting,* Vol. 1, p. 127.

[127] *Poems by Wang Wei,* No. 37.

[128] *Poems by Wang Wei,* No. 17. See Rowley, *Principles of Chinese Painting,* p. 23.

[129] Fei, *Brush Drawing,* p. 48.

[130] C. C. Shih, from *Shu Hua Fang,* Vol. III and *Hua Hsüeh Hsin Yin,* p. 17.

[131] *Kokka,* No. 196, p. 424, by Seiichi Taki.

[132] Wang Wei seems to have been an exception.

[133] Sullivan, *An Introduction to Chinese Painting,* p. 128.

[134] Waley, *An Introduction to Chinese Painting,* p. 145.

[135] Ferguson, *Chinese Painting,* p. 71.

[136] Sickman and Soper, *The Art and Archaeology of China*, p. 90 ff.
[137] Cohn, *Chinese Painting*, p. 71.
[138] Siren, *Chinese Painting*, Vol. I., p. 132.
[139] Sullivan, *An Introduction to Chinese Painting*, p. 128.
[140] Birch, *An Anthology of Chinese Literature*, p. 217.
[141] Munsterberg, *The Landscape Painting of China and Japan*, p. 38.
[142] Lee, *A History of Far Eastern Art*, p. 271.

ABOUT THE AUTHORS

LEWIS CALVIN WALMSLEY

IN 1958, DR. WALMSLEY, collaborating with Mr. Chang Yin nan, published their translation of the *Poems of Wang Wei*. In the current volume he gives us the colourful story of the poet, equally famous as a painter. Wang Wei's genius reached full flowering in that amazingly brilliant era, eighth-century T'ang China. Life in the capital at that time is intimately described here in *Wang Wei, the Painter-Poet*.

A native of Ontario, Canada, Dr. Walmsley received his bachelor and doctor's degrees from the University of Toronto. For more than twenty-five years he was Principal of The Canadian School in Chengtu, China, under the United Church of Canada. During the Sino-Japanese war Dr. Walmsley was in charge of Woodstock School, Mussoorie, India, 1945–1947. In 1948, with the advent of Communism, he returned to Toronto to join the staff of the University of Toronto, lecturing on Chinese History and Culture until he retired in 1962. That year he married his present collaborator, the former Mrs. Charles F. Brush, Jr.

In the summer of 1957 Dr. Walmsley was invited back to China for a visit by the Chinese People's Association for Estab-

lishing Cultural Relations with Foreign Countries. Given free-
dom to arrange his own itinerary, he travelled extensively through
familiar, historical and archaeologically important parts of the
country. To him the most exciting section of this six-thousand
mile journey was that area of China closely associated with the
life of Wang Wei: the environs of Ch'ang-an, now the modern
city of Si-an, capital of Shensi Province. Many places described
in *Wang Wei, the Painter-Poet* sprang into vivid reality for him:
the massive tumulus of China's first emperor, Chin Shih Huang
Ti; Warm Springs, the pleasure resort of emperors and the favour-
ite retreat of Yang Kuei-fei, China's most notorious concubine;
the city of Lan-t'ien where the Chung Lan Hills form a backdrop
to the Wang River idling across the plain. This was the world so
dear to the heart of Wang Wei, such scenes his inspiration for
landscape paintings never surpassed—like the Wang Ch'uan
Scroll.

To have seen with his own eyes Wang Wei's beloved country-
side inspired Dr. Walmsley also to bring the artist, his work, and
his times fully alive in this record.

DOROTHY BRUSH WALMSLEY

BORN IN CLEVELAND, OHIO, Mrs. Walmsley considers her-
self a missionary like her husband, though in a different field—
family planning. She graduated from Smith College which re-
cently awarded her a medal for her life work. Since 1928, closely
associated with Margaret Sanger, the birth control pioneer, she is
a founder of the International Planned Parenthood Federation
(London) and first edited its "Round the World News of Popula-
tion and Birth Control." Next, becoming the Honorary Field

Advisor for the I.P.P.F., she travelled constantly, particularly in Asia.

As Mrs. Charles F. Brush, Jr., she honeymooned (1919) in Old China for two months. In 1937 Dr. Arthur Wu, head of the Chinese Medical Association, had arranged a lecture tour for Mrs. Sanger accompanied by Mrs. Brush. They arrived in Japan only to find the plans cancelled because of the so-called "China Incident." Sailing on toward Saigon, Mrs. Brush's last glimpse of Mainland China was bombed Shanghai, burning in the night sky while six hundred Chinese refugees picked up in the harbour jammed every inch of the ship.

In the last decade, however, she has been invited three times to the National Republic of China, Taiwan, and has visited Hong Kong many more times. Mrs. Walmsley has published articles, plays, poetry, and two books. She is a member of the American Author's League.

INDEX

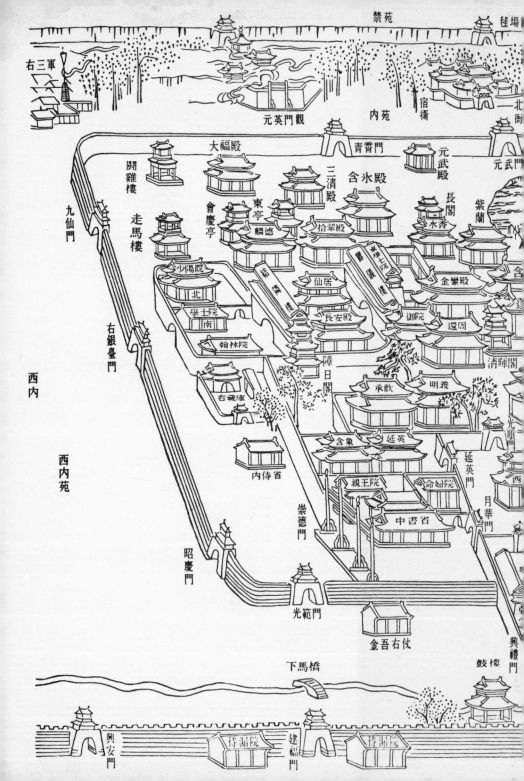